EGYPTIAN DESIGNS
IN MODERN STITCHERY

PAULINE FISCHER
text by Mary Lou Smith

EGYPTIAN DESIGNS IN MODERN STITCHERY

E. P. DUTTON / NEW YORK

ACKNOWLEDGMENTS

With thanks to my daughter Claire Kahane, who is a designer in her own right, and to my expert and enthusiastic assistants Muriel Connery and Lena Teitelbaum.

In preparing for this book quite a number of the designs had to be worked in a limited time. This would not have been possible without the help of my talented and dedicated students and friends who devoted long hours to this project: Matsuko Akiya, Ruth Corey, Ellen Fisher, Betty Goldstein, Naomi Halperin, Gisele Kaufman, Sara Lipetz, Sonny Silver, Helen Slesinger, Margot Soldinger, Irma Spyer, Rose Turtz, Mary Willig, Rella Zuckerman. **PF**

Photography by Helga Photo Studio, New York

For information contact: E.P. Dutton, 2 Park Avenue, New York,
N.Y. 10016

Library of Congress Cataloging in Publication Data
Fischer, Pauline.
 Egyptian designs in modern stitchery.

 Bibliography: p.
 Includes index.
 1. Canvas embroidery—Patterns. 2. Design,
Decorative—Egypt. I. Smith, Mary Lou. II. Title.
TT778.C3F574 1979 746.4′4 78-11162
ISBN 0-87690-316-2

Published simultaneously in Canada by Clarke, Irwin & Company
Limited, Toronto and Vancouver

EDITED BY PACE BARNES
DESIGNED BY BETTY BINNS

10 9 8 7 6 5 4 3 2 1

FIRST EDITION

To my husband Maurice, who has been my
organizer, researcher and counselor.
Without him I could not have made it.

P.F.

To my husband Will Carr, my children
Mary Eliza, William, Susan and John T.,
and especially to my sister Pace who is
a designing woman herself.

M.L.S.

CONTENTS

KING TUTANKHAMUN

HIEROGLYPHS

PREFACE

This book was inspired by a fascination with the lore and history of ancient Egypt, and with it a love for the art of needlework. In its pages we hope you will find our many projects rich in color and feeling and authentic in design, yet relatively simple to work.

The discovery of the tombs of the ancient kings of Egypt, particularly that of King Tutankhamun, unearthed a splendor of design in jewelry and home furnishings, in sculpture and in the visual arts. Although the designs are many thousands of years old, they continue to be exciting today. Most of the motifs are taken from nature, and many have been used in the preparation of this book.

The ancient Egyptian color palette is a simple one containing few colors, but it is made interesting by the sophisticated arrangement of these blues, reds and greens. There is, too, a rich earthy look to Egyptian design, which is very much in keeping with today's emphasis on such natural materials as straw, reed, and bleached woods. Along with the modern adaptations of the designs shown here, we hope you will find excitement in the new stitches and stitch variations developed especially for this book by Pauline Fischer.

One of them, the Half-cross Skip stitch seen on the Royal Leopard, is worked rapidly and provides textural contrast with the more traditional Satin, freeform Bargello, and Continental stitches used in this striking portrait. The Glossary of New Stitches illustrates this and all the other new stitches, along with directions and photographs showing how to work them.

Just as *Bargello Magic* introduced the concept of creating your own patterns by varying color to alter design, *Egyptian Designs in Modern Stitchery* presents the idea of using canvas as part of the design. Bast the Cat Goddess, the Anubis and the Desert Ibex demonstrate the marvelous new effects that can be achieved in this way and in much less time than that needed to complete an average project.

Each design in the book is photographed in color and is shown again full size in a brown and black photo-pattern. This new method for presenting needlework patterns provides the reader with a design partially worked to allow for tracing, counting mesh and threads, and even copying unfamiliar stitches directly from the book. Brief written instructions are given for each design, and each pattern has a key for the stitches used and in some instances a color key too. Many projects can be successfully worked on smaller or larger mesh canvas, and also in many the wool, cotton, silk and metallic threads can be substituted, one for another, for special effects in texture. You might even try to fill in some of the backgrounds that are left unworked in the original pieces, or use another stitch in place of the one suggested.

We hope you will respond to this book as the archaeologist, Howard Carter, did when he first peered into King Tutankhamun's tomb and was asked if he could see anything. His reply, after a long silence, was "Yes, wonderful things!" We also hope you receive as much pleasure in working the designs as we did in planning, designing and describing them.

HISTORICAL SOURCES

Carter, Howard. *The Tomb of Tutankhamen.* New York: E. P. Dutton, 1972.

Casson, Lionel and Editors of *Time-Life Books. Ancient Egypt: Great Ages of Man.* New York: Time Inc., 1965.

Champollion, Jacques. *The World of the Egyptians.* Geneva: Minerva L. A., 1971.

Desroches-Noblecourt, Christiane. *Tutankhamen.* New York: New York Graphic Society, 1963.

Encyclopedia of World Art, vol. IV. New York: McGraw Hill Book Company, 1968.

Lange, Kurt, with Max Hermer. *Agypten.* Munchen: Mermer Dulap, 1975.

Metropolitan Museum of Art. *Treasures of Tutankhamen.* New York: Metropolitan Museum of Art, 1976.

Murray, Margaret A. *The Splendor That Was Egypt.* New York: Hawthorne Books, 1963.

Phaidon Books. *The Egyptian Kingdom.* New York: E. P. Dutton, 1975.

Scott, Joseph and Lenore. *Egyptian Hieroglyphs for Everyone.* New York: Funk & Wagnalls, 1968.

GENERAL DIRECTIONS

Egyptian Designs in Modern Stitchery was conceived for the needle-crafter who has worked in several areas of embroidery, although the inexperienced reader should not hesitate to attempt the designs since most are easy to work, and clear, simple directions have been written for them. While this is not a basic needlecraft book explaining all stitches and materials—many other excellent books do this—certain rules and reminders are helpful as a guide.

MATERIALS

Use the best materials available to warrant the amount of effort put into a piece of work. Feel free to experiment using colors and mesh size different from those given at the beginning of each project. Try different background stitches or border designs, but remember when you substitute to adjust the weight or texture of the threads and make any other alterations necessary. Realize also that changing the mesh size will change the size of the design.

Canvas: All of the designs are worked on mono canvas and in most cases the color of the canvas is important to the design of the piece itself and should be used as specified. Canvas size and finished size are given for each project, with the horizontal dimension listed first.

Stretchers or frames: The designs in this book should be worked on wooden frames or stretchers to prevent the finished piece from warping, and to avoid having to block it. Many different stitches are used in all of the designs, and the stretcher is needed for the stability of the canvas. It also allows for the use of the "stab" method of stitching which, though a little more time consuming, helps further to prevent the distortion of the canvas. An artists stretcher or a rotating frame is recommended. In a few cases only a rotating frame will be suitable because of the length of the piece. The artists stretcher size is given for each design where applicable, again with the horizontal dimension listed first. No stretcher measurements are provided for the rotating tapestry frame, since it is adjustable for different sizes of canvas. Both types of stretchers are relatively inexpensive and may be obtained from supply stores, yarn shops and other arts and crafts sources.

As a general rule the stretcher frame should be 4 inches larger on all sides than the finished piece of needlework, including the allowance left for sewing or mounting. This allowance is usually no less than 2 inches all around; therefore, a piece of canvas required to work a finished piece 17" x 17" should be 21" x 21". The artists stretcher should also be 21" x 21". Keep the stretcher size to a minimum for ease in handling and portability.

Wool and cotton threads: The colors used in this book are keyed to Paternayan Persian wools and DMC cottons. The numbers in parentheses indicate colors from the color charts found in most needlework supply stores. Persian wools come in 3 ply and can be separated into 3 strands. The number of strands to be used will be specified in the instructions for each design. Both Pearl Cotton and 6-strand cotton have been used and are specified throughout the book. The color numbers for the two types of cotton threads are the same, but it is important to use them as directed. The Pearl Cotton is a twisted cotton and has been used in two different weights or sizes: no. 3 and no. 5. Where a Pearl Cotton is not suitable, a 6-strand cotton has been substituted. Unless otherwise directed, all cotton threads are used as they come from the package, or full ply.

Metallic and silk threads: Metallic and silk threads are often used in the designs to give added richness. If you prefer, a gold cotton thread or a corresponding color for the silk threads may be substituted. However, if metallic and silks are used, they need special handling. After the needle is threaded, use beeswax on the ends to help prevent fraying. This can be

purchased at most yarn shops or stores where sewing notions are sold. Always work metallic threads into a design first so as not to rough up other threads, particularly silks and cottons. When directions call for metallic or other threads to be doubled, do not thread two pieces through the eye of the needle, but rather one thread doubled. This will relieve the bulk of four pieces of thread being pulled through the canvas, and will still give the desired thickness called for. Wool and cotton requirements are not given but most yarn supply sources can assist you in figuring this. In buying these materials it is essential that you purchase sufficient amounts of the colors to be used from the same dyelot or make sure that the dyelot will be available until you have finished working the piece. A color can change noticeably from dyelot to dyelot.

WORKING THE DESIGNS

To transfer the designs from the book use one of the following methods: (1) Mark the top center of the canvas. Trace the design on tracing paper or on acetate with a heavy line, using a black Sharpie pen. On a flat work surface, place this tracing under canvas, having first placed a sheet of white paper under the tracing paper. Using a medium gray indelible marking pen, transfer the design onto the canvas. (2) For counted stitch designs such as Lotus and Buds the design should be counted directly from the photo-pattern or graphed and then worked as the reader prefers. If this method is used mark the canvas at the top center and place guidemarks wherever needed.

Mounting the canvas: After the design has been transferred, mount the canvas on the stretcher with the canvas taut, staple or tack it in place with rust-proof thumbtacks or staples, then tape the edges with masking tape all around the frame to hold it securely in place and to prevent the edges of the frame from splintering.

Once the canvas has been prepared, make a palette of colors to be used, by tying a few threads of each color on the side of the canvas. If there is not room on the stretched piece, use an extra small piece of canvas.

Stitch and color keys: Stitches are specified under directions for each design, and each has a brown and black photo-pattern accompanying the directions. This pattern is sharp enough to allow for direct copying and is keyed for the stitches used. Written directions are given for each de-

sign, and for added clarity some of the patterns are also keyed for color. Stitches are keyed by letters, the colors by numbers.

New stitches are marked with an asterisk (*), and detailed instructions for working them are shown in the Glossary of New Stitches. Familiar stitches such as the Continental, Gobelin, and Chain stitch are not described but may be found in any good stitch dictionary, a number of which are included here:

Alderson, Chottie. *Stitchin' with Chottie.* California: Lady Bug Series, 1975.

Bucher, Jo. *Embroidery Stitches and Crewel.* Des Moines: Meredith Corporation, 1971.

Christensen, Jo Ippolito. *The Needlepoint Book.* New Jersey: Prentice-Hall, 1976.

Gostelow, Mary. *Mary Gostelow's Embroidery Book.* New York: E. P. Dutton, 1979.

Snook, Barbara. *Needlework Stitches.* New York: Crown, 1972.

Thomas, Mary. *Mary Thomas's Dictionary of Embroidery Stitches.* London: Hodder & Stoughton, 1934; reprinted 1968.

Wilson, Erica. *Erica Wilson's Embroidery Book.* New York: Charles Scribner's Sons, 1973.

FINISHING THE PROJECTS

Many books and magazines give directions for making your own projects, such as *Blocking and Finishing* by Dorothy Burchette (Charles Scribner's Sons, New York, 1974). Local sources such as picture framers, upholsterers and special repair shops are available for assembling completed pieces and can be located through the *Yellow Pages.* For custom work, we recommend:

Modern Leather Goods Repair Shop
11 W. 32nd Street
New York, N.Y. 10001
Needlepoint mounting; leather handbags

Artbag Creations
735 Madison Avenue
New York, N.Y. 10021
Needlepoint mounting; handbags

J. Pocker & Son
824 Lexington Avenue
New York, N.Y. 10021
Framing

purchased at most yarn shops or stores where sewing notions are sold. Always work metallic threads into a design first so as not to rough up other threads, particularly silks and cottons. When directions call for metallic or other threads to be doubled, do not thread two pieces through the eye of the needle, but rather one thread doubled. This will relieve the bulk of four pieces of thread being pulled through the canvas, and will still give the desired thickness called for. Wool and cotton requirements are not given but most yarn supply sources can assist you in figuring this. In buying these materials it is essential that you purchase sufficient amounts of the colors to be used from the same dyelot or make sure that the dyelot will be available until you have finished working the piece. A color can change noticeably from dyelot to dyelot.

WORKING THE DESIGNS

To transfer the designs from the book use one of the following methods: (1) Mark the top center of the canvas. Trace the design on tracing paper or on acetate with a heavy line, using a black Sharpie pen. On a flat work surface, place this tracing under canvas, having first placed a sheet of white paper under the tracing paper. Using a medium gray indelible marking pen, transfer the design onto the canvas. (2) For counted stitch designs such as Lotus and Buds the design should be counted directly from the photo-pattern or graphed and then worked as the reader prefers. If this method is used mark the canvas at the top center and place guidemarks wherever needed.

Mounting the canvas: After the design has been transferred, mount the canvas on the stretcher with the canvas taut, staple or tack it in place with rust-proof thumbtacks or staples, then tape the edges with masking tape all around the frame to hold it securely in place and to prevent the edges of the frame from splintering.

Once the canvas has been prepared, make a palette of colors to be used, by tying a few threads of each color on the side of the canvas. If there is not room on the stretched piece, use an extra small piece of canvas.

Stitch and color keys: Stitches are specified under directions for each design, and each has a brown and black photo-pattern accompanying the directions. This pattern is sharp enough to allow for direct copying and is keyed for the stitches used. Written directions are given for each de-

sign, and for added clarity some of the patterns are also keyed for color. Stitches are keyed by letters, the colors by numbers.

New stitches are marked with an asterisk (*), and detailed instructions for working them are shown in the Glossary of New Stitches. Familiar stitches such as the Continental, Gobelin, and Chain stitch are not described but may be found in any good stitch dictionary, a number of which are included here:

Alderson, Chottie. *Stitchin' with Chottie.* California: Lady Bug Series, 1975.

Bucher, Jo. *Embroidery Stitches and Crewel.* Des Moines: Meredith Corporation, 1971.

Christensen, Jo Ippolito. *The Needlepoint Book.* New Jersey: Prentice-Hall, 1976.

Gostelow, Mary. *Mary Gostelow's Embroidery Book.* New York: E. P. Dutton, 1979.

Snook, Barbara. *Needlework Stitches.* New York: Crown, 1972.

Thomas, Mary. *Mary Thomas's Dictionary of Embroidery Stitches.* London: Hodder & Stoughton, 1934; reprinted 1968.

Wilson, Erica. *Erica Wilson's Embroidery Book.* New York: Charles Scribner's Sons, 1973.

FINISHING THE PROJECTS

Many books and magazines give directions for making your own projects, such as *Blocking and Finishing* by Dorothy Burchette (Charles Scribner's Sons, New York, 1974). Local sources such as picture framers, upholsterers and special repair shops are available for assembling completed pieces and can be located through the *Yellow Pages.* For custom work, we recommend:

Modern Leather Goods Repair Shop
11 W. 32nd Street
New York, N.Y. 10001
Needlepoint mounting; leather handbags

Artbag Creations
735 Madison Avenue
New York, N.Y. 10021
Needlepoint mounting; handbags

J. Pocker & Son
824 Lexington Avenue
New York, N.Y. 10021
Framing

14

The Egyptians' belief in the afterlife and their preparation for it affords us a clear picture of how they lived, what they ate, what they wore, and what they did for work and pleasure. This entire civilization was revealed to us through the excavation of their tombs. A look back to some 4000 years B.C. has intrigued man and influenced his art, since the first tomb was discovered.

The Egyptians lived a simple, leisurely life in pleasant, luxurious surroundings. Animals played an important part in their activities and provided food and sport through hunting and fishing. Some animals were domesticated and others were kept in the home as beloved pets; many were deified because they were thought to represent certain gods. Plants too, particularly the lotus and the papyrus, had a special significance for the Egyptians besides being appreciated for just their beauty and fragrance. Other symbols of importance to them, such as the scarab and the Wedjet Eye, were used as amulets to protect the wearer from harm.

The art of these conservative people was always simple in line and color. It was very dignified with a feeling of solidity and stability. Their artistic expressions were intended to remain the same year after year, and this is perhaps what has made it so timeless and appealing to us today.

PART I

LIFE OF ANCIENT EGYPTIANS

LOTUS
FLOWER

The ancient Egyptians loved gardens and flowers, and their favorite was the blue lotus because of its fragrance and color. An important symbol of authority in upper Egypt, the flower is seen repeatedly as a design motif in Egyptian sculpture and paintings, and also as a pattern for jewelry.

This majestic example is worked with a few simple stitches, but the interesting arrangement of color makes it appear more intricate. The vivid greens remind us that old designs can become new with the use of today's palette. An ideal piece for the beginning needleworker, even a child might find it fun to work.

THE LOTUS FLOWER IS DESIGNED TO BE USED AS A RUG, WALL HANGING, BENCH COVER OR FAN-SHAPED PILLOW.

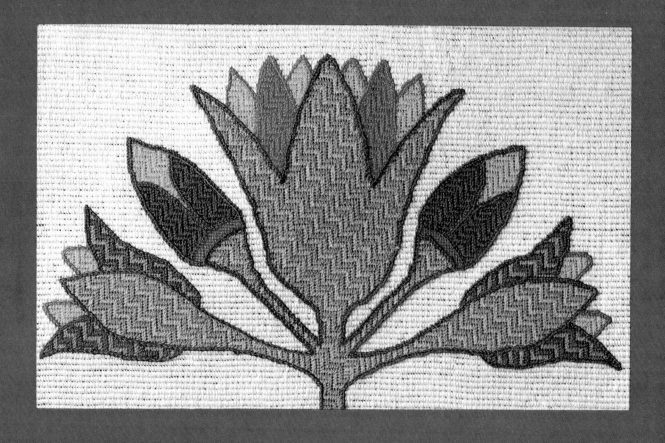

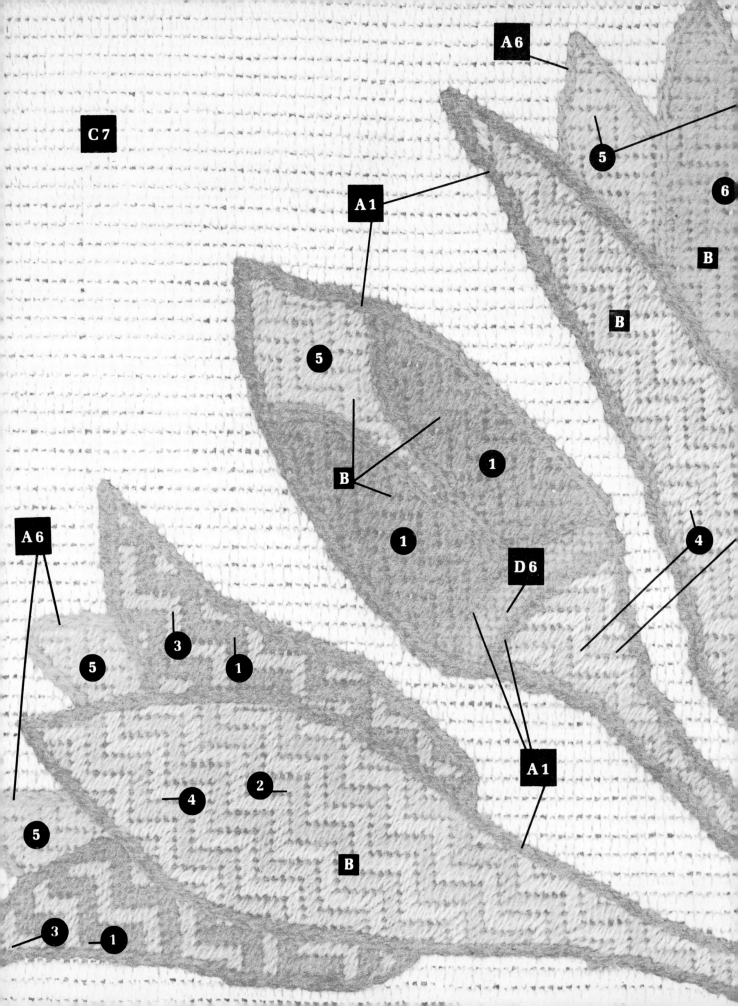

A Chain
B Byzantine
C Gobelin
D Continental

INSTRUCTIONS

Canvas: 10-mesh white mono canvas (26″ x 18″)
Needle: no. 18 tapestry
Stretcher: 26″ x 18″
Finished size: 22″ x 14″

Persian wool

1. dark green (G54)
2. medium green (G64)
3. light medium green (574)
4. light green (G74)

5. yellow (450)
6. orange (960)
7. white

Working the design

Mark the center top of the canvas. Trace the right half of the design onto tracing paper. Turn the paper over, darkening markings if necessary, and copy the left side of the design. Transfer the complete design onto the canvas and prepare to work using method described under General Directions.

1. Outline the entire design in Chain stitch (A), using 2 strands of dark green wool for the darker outline (1), and 2 strands of orange wool (6) for the lighter outline.

2. Fill inside of flowers and buds with Byzantine stitch (B), using 2 strands of wool and working over 2 canvas threads. Colors are keyed above to photo-pattern.

Working the background

Work in straight Gobelin (C), using 3 strands of white wool and working over 2 canvas threads.

20

BAST THE CAT GODDESS

The cat, a beloved pet of the early Egyptians, was also one of their incarnated deities, and its feline figure was often found in their art, particularly in a sculptural form. Inspiration for this design was found in a Late Dynasty bronze representation of Bast (664–332 B.C.).

In this charming piece of needlework the majestic animal stands out almost three-dimensionally because of the interesting use of the padding and overlaying seen in the stitch embroidered on its body. This stitch—the Egyptian Couching stitch—is a new variation of the familiar couched stitch. To further enhance the background of the unusual animal another new repeat stitch was developed —the Kalem Lotus stitch.

BAST THE CAT GODDESS IS DESIGNED TO BE USED AS A WALL HANGING, PILLOW, BENCH COVER, TOTEBAG OR CHAIR BACK.

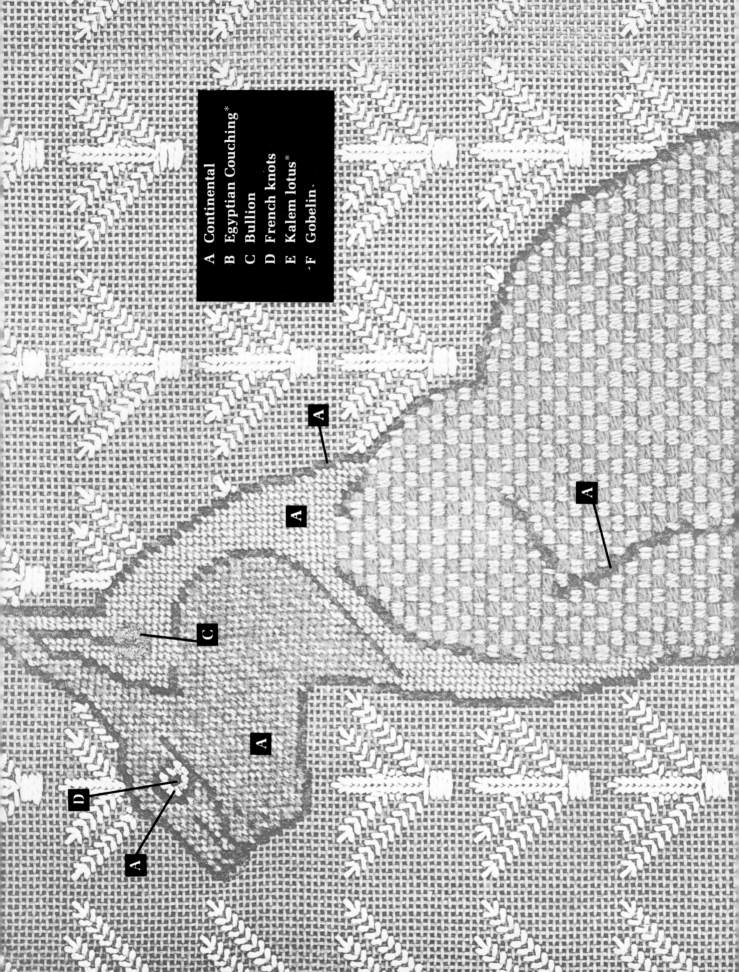

A Continental
B Egyptian Couching*
C Bullion
D French knots
E Kalem lotus*
F Gobelin

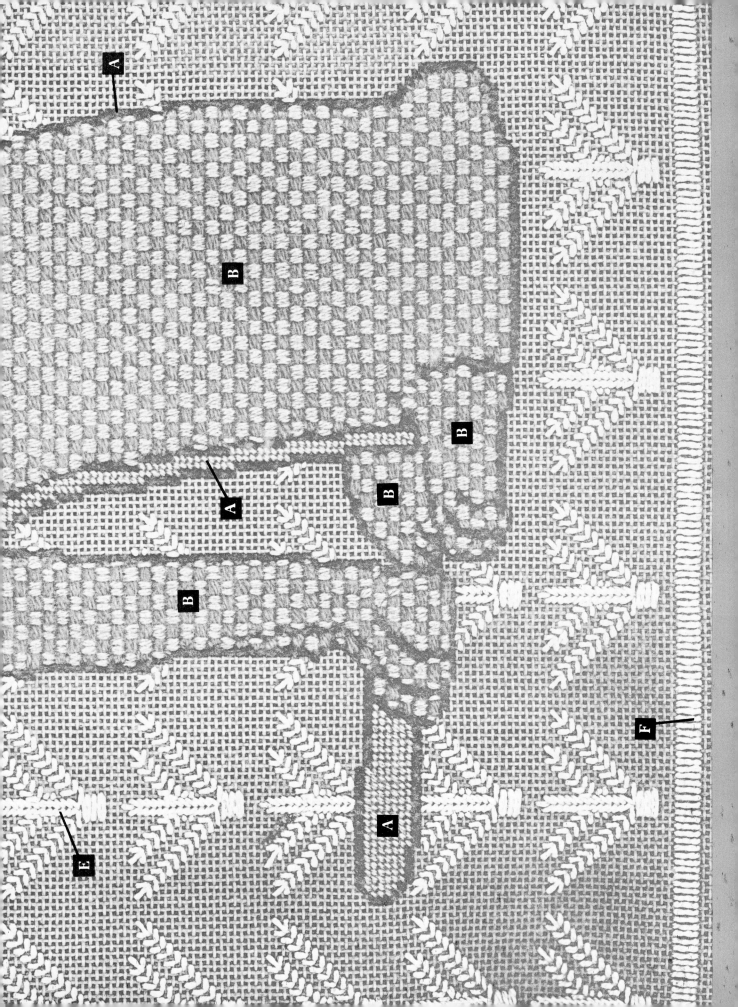

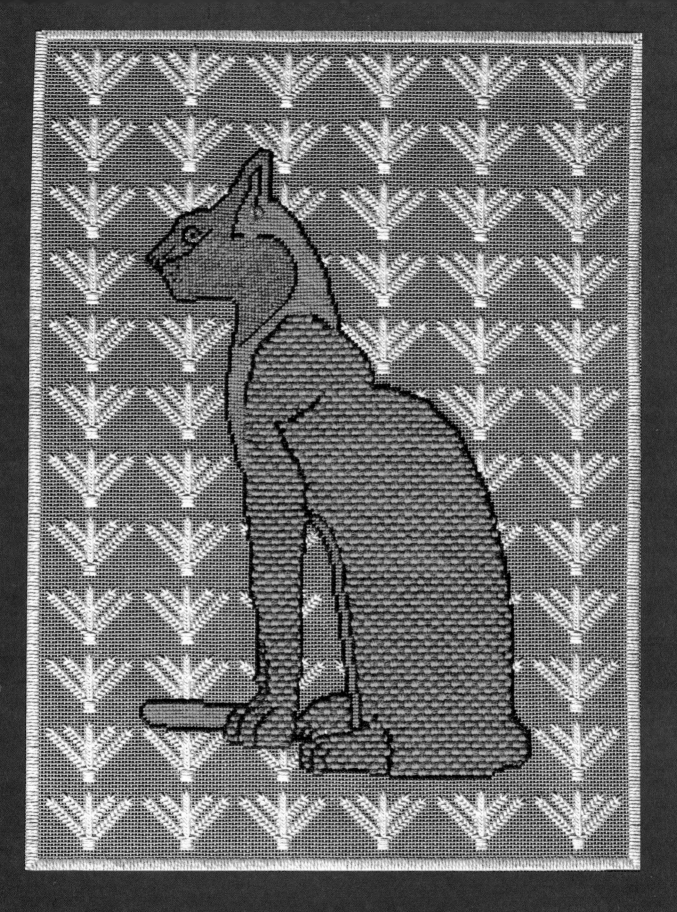

INSTRUCTIONS

Canvas: 14-mesh ecru mono canvas (18″ x 22″)
Needles: no. 20 tapestry for wool threads
no. 18 tapestry for cotton, silk and metallic threads
Stretcher: 18″ x 22″
Finished size: 14″ x 18½″

Persian wool	*Other threads*
dark turquoise (718)	black DMC Pearl Cotton no. 3
medium turquoise (728)	ecru DMC Pearl Cotton no. 3
	gold metallic
	yellow Marlitt silk

Working the design

Transfer the figure of the cat and prepare to work, using the method described under General Directions.

1. Cat: Outline the cat in Continental (A), using black Pearl Cotton. Work other dark lines of body in Continental (A), using black Pearl Cotton.

2. Body: Work heavy textured area in Egyptian Couching stitch (B),* using 4 strands of dark turquoise wool for the padding and 2 strands of medium turquoise wool for the overstitch.

3. Back of head, neck and tail: Work in Continental (A), using 2 strands of medium turquoise wool. Work into shaded area, using color illustration as guide.

4. Face and throat: Work in Continental (A), combining 1 strand of medium turquoise and 1 strand of dark turquoise wool to create an interesting shaded effect.

5. Earring: Work in Bullion stitch (C), using gold metallic thread.

6. Eye: Work in Continental (A), using 2 strands of yellow silk. Work French Knot (D) in center of eye, using black Pearl Cotton.

Working the background

Work in Kalem Lotus stitch (E),* using ecru Pearl Cotton. Follow photo-pattern for placement of stitches.

*See Glossary of New Stitches.

Working the border

Work after the background is completed in straight Gobelin (F), over 4 canvas threads, using ecru Pearl Cotton. Place the border an equal number of free mesh from top, bottom and sides of the finished background. Miter the corners.

RAM'S HEAD

Two main breeds of sheep were domesticated by the ancient Egyptians, and the male of one of these had heavy recurved horns. A striking limestone bas-relief of the head was found in a tomb of the Ptolemaic Period, 332–30 B.C.

The design, shown here, was adapted from that fragment of sculpture, and it is worked in four levels of stitches to capture the depth of the original. This is achieved through heavy Bullion coils to show one level of the design, padded Brick for the second level, Continental or Diagonal Tent and Half-cross Skip stitch for the third and Pulled Thread stitch for the background.

A border of Egyptian or Eastern stitch can be used in the mounted ram's head.

THE RAM'S HEAD IS DESIGNED TO BE USED AS A WALL HANG-
ING OR PILLOW.

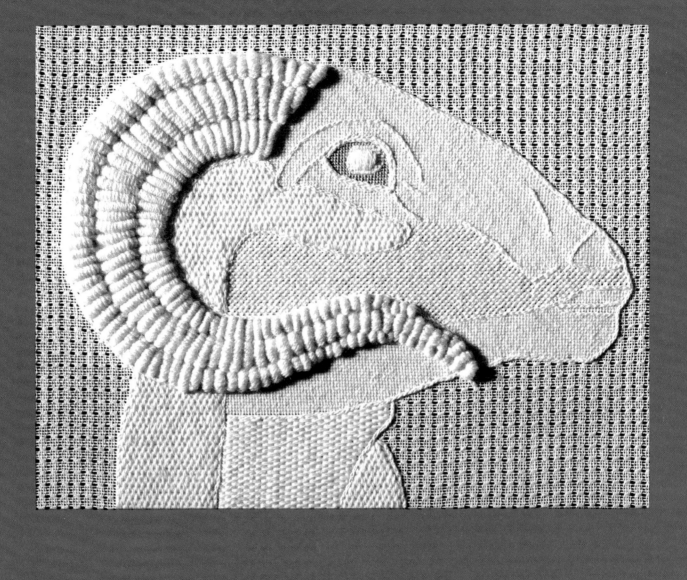

INSTRUCTIONS

Canvas: 14-mesh white mono canvas (20″ x 16″)

Needles: no. 13 tapestry or rug needle for Bullion stitches
 no. 20 tapestry for wool threads
 no. 18 tapestry for cotton threads

Stretcher: 20″ x 16″

Finished size: 16″ x 12″

Threads
white Persian Wool
white DMC Pearl Cotton no. 3
white DMC Pearl Cotton no. 5

Working the design

Transfer the design and prepare to work, using the method described under General Directions.

1. Head: Outline the head in Chain stitch (A), using white Pearl Cotton no. 3. Work all lines in face and outer edge of horn in Chain stitch (A), using white Pearl Cotton no. 3. The outline of the eye and inside curve of the horn are worked in a double row of Chain stitch, also using white Pearl Cotton no. 3.

2. Upper cheek: Work in Tramé Brick stitch (B), using 3 strands of white wool for the padding and 2 strands of white wool for the overstitch.

3. Lower cheek: Work in Half-cross Skip stitch (G).*

4. Eye: Work pupil in Tramé Gobelin stitch (C), using 3 strands of white wool for the padding and for the overstitch. Work the rest of the eye in Continental (D), using 2 strands of white wool.

5. Face: Work in Continental or Diagonal Tent (D), using 2 strands of white wool.

6. Neck: Work in horizontal brick (B).

7. Horns: Use no. 13 rug needle. Pad the area to be worked for the horns with 6 strands of white wool. Work the three rows of Bullion stitches (E) as follows:

 Outer Row: Bullion stitch has 8 coils each. Use 6 strands of white wool to make each coil.

 Middle Row: Bullion stitch has 12 coils each. Use 6 strands of white wool to make each coil.

 Inner Row: Bullion stitch has 14 coils each. Use 3 strands of white wool to make each coil.

Decrease size and number of coils toward point of the horn as shown in photo-pattern.

Working the background

Work in Pulled Thread stitch (F).* Work vertically over 4 canvas threads, using white Pearl Cotton no. 5.

*See Glossary of New Stitches. 29

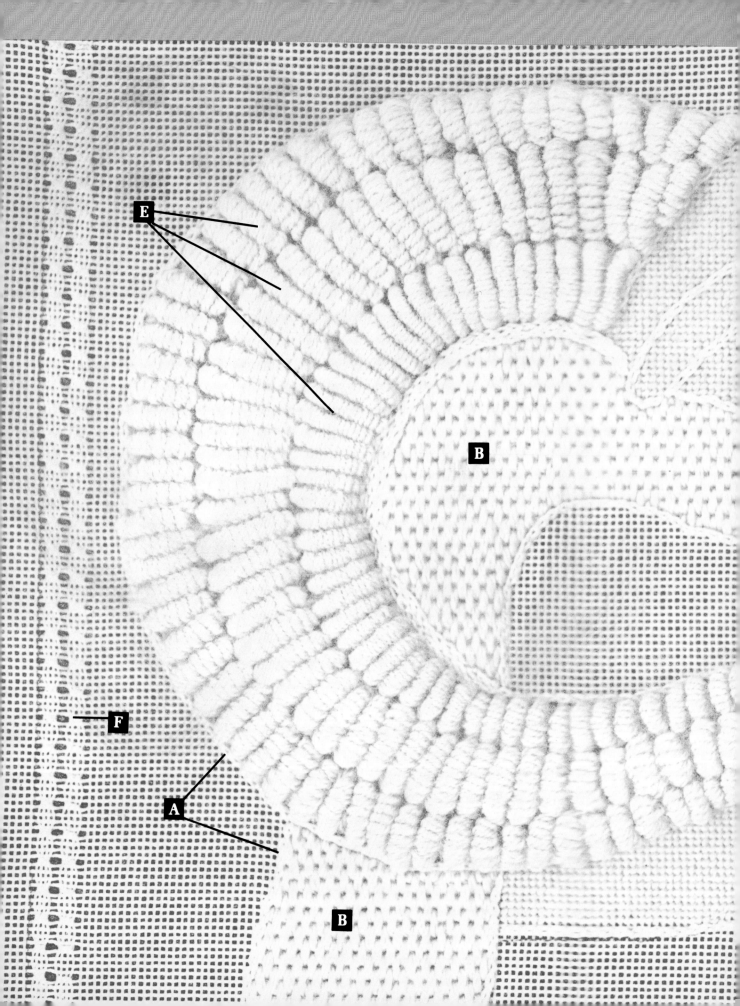

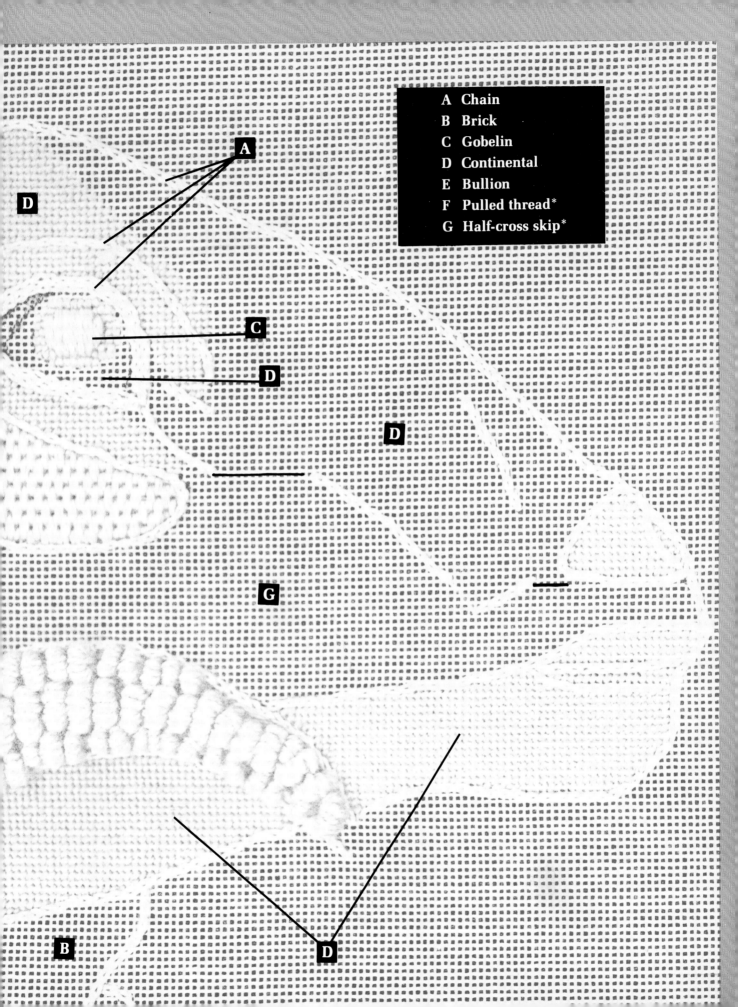

A Chain
B Brick
C Gobelin
D Continental
E Bullion
F Pulled thread*
G Half-cross skip*

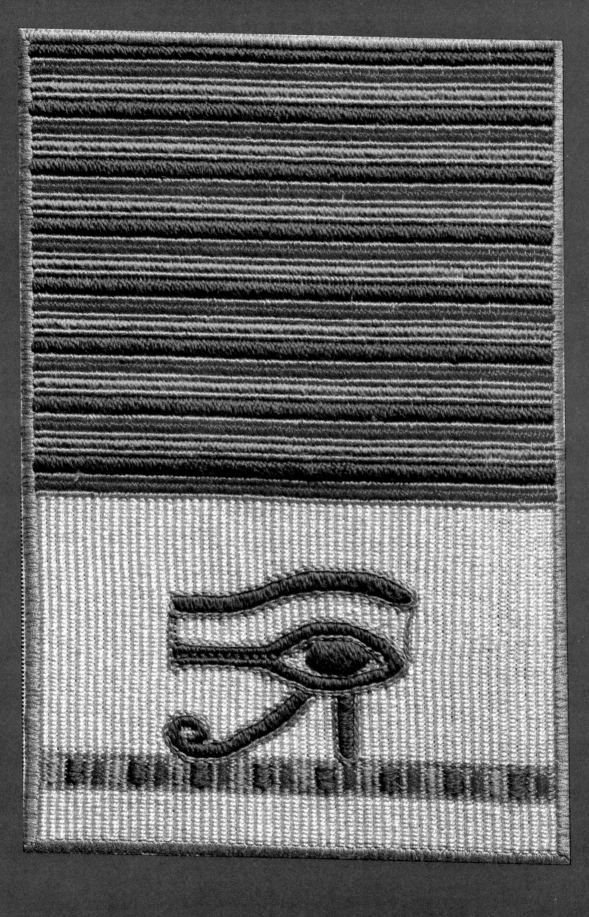

WEDJET EYE

The eye was considered magical by many early people. It was one of the holiest symbols of Egyptian religion, and was identified with both the sun and the moon during different periods of history.

For esthetic as well as ritual reasons both men and women painted their eyes with dark paints to elongate and emphasize them. This rendering of the eye is seen over and over again in many forms of Egyptian arts and crafts. Called the Wedjet Eye or Eye of Horus, it was a symbol of protection, and also a promise of a reconstitution or rebirth of the body. The inspiration for this symbol and the border design of this striking purse came from the Tomb of Sennefer, a mayor of Thebes. His richly embellished tomb was built during the fifteenth century B.C., and it is an important point of interest for many tourists visiting Egypt today.

THE WEDJET EYE IS DESIGNED TO BE USED AS A PURSE, PILLOW OR ALBUM COVER.

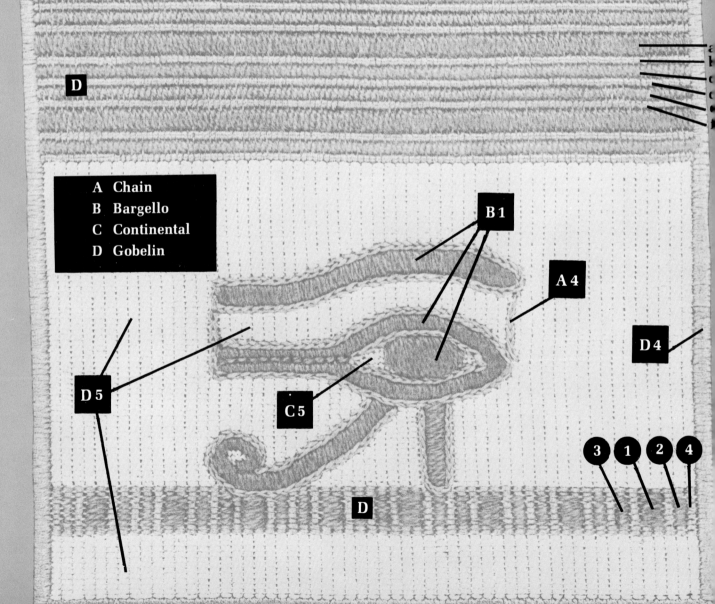

Work the stripes in vertical Gobelin (D) in the following order from the top:

a. medium dark blue wool (work over 4 canvas threads)
b. gold 6-strand cotton (work over 1 canvas thread)
c. coral wool (work over 2 canvas threads)
d. gold 6-strand cotton (work over 1 canvas thread)
e. aqua wool (work over 2 canvas threads)
f. gold 6-strand cotton (work over 1 canvas thread)

Repeat steps a, through f six more times.
Repeat steps a, b, c, and d one more time.
NOTE: The sequence will end with a gold stripe.

D

A Chain
B Bargello
C Continental
D Gobelin

B 1

A 4

D 4

D 5

C 5

D

3 1 2 4

INSTRUCTIONS

Canvas: 18-mesh white mono canvas (11" x 14")
Needle: no. 18 tapestry
Stretcher: 11" x 14"
Finished size: 7½" x 10¾"

Persian wool	*Other threads*
1. medium dark blue (763)	4. medium gold DMC 6-strand
2. coral (843)	cotton (729)
3. aqua (G32)	5. ecru DMC Pearl Cotton no. 3

Working the design

Transfer the design and prepare to work, using the method described under General Directions.

1. Eye: Outline the eye in Chain stitch (A), using medium gold 6-strand cotton. Fill outlined areas with Bargello (B), using 2 strands of medium dark blue wool. Work white of eye in Continental (C), using ecru Pearl Cotton.

2. Multicolored band: Work the band under the eye in horizontal Gobelin (D). See photo-pattern for key to colors and thread count of canvas. Repeat sequence from right to left as established.

3. Stripes: Work in vertical Gobelin (D). See photo-pattern for key to colors and thread count of canvas (top border and stripe sequence are not shown on photo-pattern).

Working the background

Work the background in horizontal Gobelin (D) over 2 canvas threads, using ecru Pearl Cotton.

Working the border

The border or frame of the purse is worked in Gobelin (D)—vertical for the top and bottom edges and horizontal for the sides, using medium gold 6-strand cotton. Work over 3 canvas threads for the sides.
NOTE: Work 1 row of Back stitch where vertical and horizontal stitches meet between frame and background to cover exposed canvas.

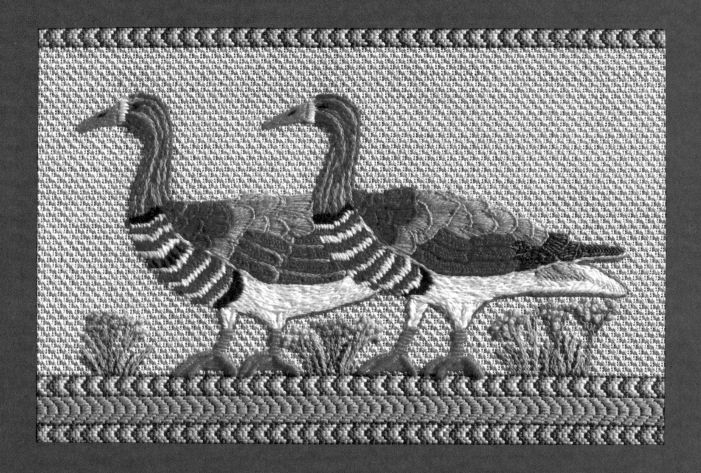

MARCHING GEESE FROM MEDUM

Ducks and geese were domesticated as well as hunted for sport in the ancient days of Egypt. This charming pair are adapted from a wall painting found in the Tomb of Itet, a court official who was buried in the city of Medum. This design, worked primarily with traditional crewel stitches on canvas, will appeal to the reader who enjoys freeform stitchery.

MARCHING GEESE FROM MEDUM IS DESIGNED TO BE USED AS A PILLOW, TRAY INSERT OR WALL HANGING.

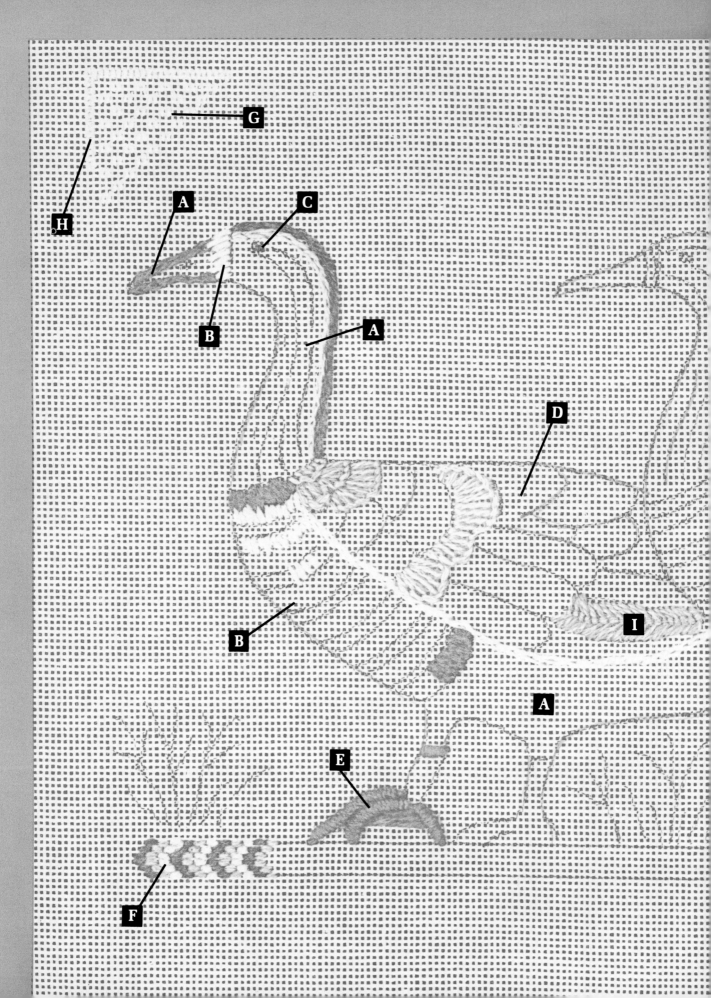

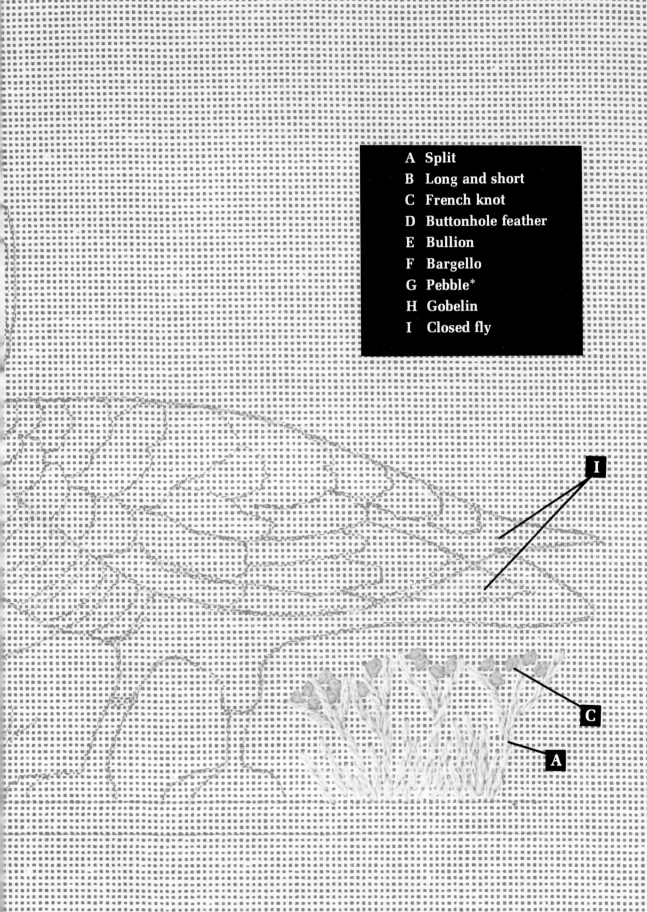

A Split
B Long and short
C French knot
D Buttonhole feather
E Bullion
F Bargello
G Pebble*
H Gobelin
I Closed fly

INSTRUCTIONS

Canvas: 16-mesh white mono canvas (15″ x 10″)
Needle: no. 20 tapestry
Stretcher: 15″ x 10″
Finished size: 11″ x 6″

Persian wool	*Other thread*
orange (960)	wheat DMC Pearl Cotton no. 3 (738)
rusty brown (247)	
medium brown (249)	
dark teal blue (367)	
light teal blue (352)	
yellow (442)	
white	
black	

Working the design

Transfer the design, using tracing paper, and prepare to work, using the method described under General Directions. Draw a horizontal line under the feet of the geese to define the area for the Bargello border. Refer to photo-pattern for details of stitches and colors.

GEESE

1. Beak: Work in Split stitch (A), using 2 strands of orange wool. For white line between beak and head, work in horizontal Long and Short stitch (B), using 2 strands of white wool.

2. Head and neck: Work in Split stitch (A). Alternate colors, using 2 strands of medium brown wool, and 2 strands of rusty brown wool.

3. Eye and nostril: Using 2 strands of black wool, work the eye in French Knot (C) and the nostril in Split stitch (A).

4. Wings: Work top wings in Buttonhole Feather stitch (D), using 2 strands of rusty brown wool and 2 strands of medium brown wool. Long feathers underneath are worked in a Closed Fly stitch (I), using 2 strands of rusty brown wool. The tip feathers and tail of the front goose are worked in a Closed Fly stitch (I), using 2 strands of dark teal blue. The light teal blue area is also worked in a Closed Fly stitch (I).

5. Breast: Work the feathers in Long and Short stitch (B), using 2 strands of the following colors of wool: black, white and rusty brown.

6. Underbody: Work the feathers in Split stitch (A), using 2 strands of white wool. Outline with Split stitch (A) using 2 strands of rusty brown wool.

7. Feet: Work the feet in Bullion stitch (E), using 2 strands of orange wool.

MARSH FLOWERS

Work the stems and leaves in Split stitch (A), using 2 strands of light and dark teal blue wool. Work the flower buds in French Knot (C), using 2 strands of orange and yellow wool.

Working the bargello borders

BOTTOM BORDER

Top and Bottom bands: Work in horizontal Bargello over 2 canvas threads using two strands and alternating the following colors of wool, dark teal, light teal and white.

Middle band: Work in horizontal Bargello over 4 threads using 2 strands of light teal wool. See color illustration.

TOP BORDER

Work only one band in the same manner as for top and bottom bands.

Working the background

Work in Pebble Stitch (G),* using wheat Pearl Cotton, or as an alternative, fill in completely with the Pebble stitch, using 1 strand of white wool. Complete piece by working a row of Gobelin (H) around the entire background, using 1 strand of white wool over 2 canvas threads and leaving 1 canvas thread free between each stitch.

*See Glossary of New Stitches.

THEBAN POND

In early days in Egypt the people were fun-loving, enjoying fishing and hunting for recreation as well as food. Fish and fowl are frequently depicted in scenes found decorating tombs and temples. Following is a needle painting adapted from a wall decoration discovered in the Tomb of Ken-Amun at Thebes. Viewed from the top of the pond, as is the original, the Theban Pond is for the advanced needleworker since it incorporates many embroidery stitches, not usually worked on canvas: wool and cotton threads, netting created with silver metallic thread as well as colorful beads.

There are many motifs in the picture which could be worked as small designs for boxes, purses, book covers, pin cushions, or coaster inserts.

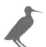

THE THEBAN POND IS DESIGNED TO BE USED AS A WALL HANGING, PILLOW OR TRAY INSERT.

42

INSTRUCTIONS

Canvas: 18-mesh white mono canvas (14″ x 20″)
Needle: no. 20 tapestry
Stretcher: 14″ x 20″
Finished size: 10½″ x 16½″

Persian wool

light yellow green (570)
medium yellow green (555)
grass green (510)
dark yellow green (505)
medium turquoise (738)
dark turquoise (718)
off-white taupe (153)
medium taupe (133)
dark taupe (123)
white

Other threads
DMC 6-strand Cotton
 medium blue (813)
 dark blue (825)
 medium orange (971)
 dark orange (947)
 gray (762)
 black
silver and gold metallic

Other materials
small orange beads
small plastic beads

Working the design

Transfer the design, using tracing paper, and prepare to work, using the method described under General Directions.

BACKGROUND

Work the background first. It is important to establish the Bargello (A) ripple pattern before starting figures on the pond. Alternate rows of medium blue 6-strand cotton, worked over 4 canvas threads, in a 4-1 step pattern with rows of dark blue 6-strand cotton doubled worked over 3 canvas threads in a 3-1 step pattern.

FISH

1. Outline fish in Chain stitch (B), using black 6-strand cotton.

2. Body: Lay long horizontal stitches on the body of the fish, using medium orange 6-strand cotton doubled. Sew several small orange beads on the body. Work silver metallic thread into a net covering the beads and body, in Buttonhole Filling-Open stitch (C),* attaching the net only along the sides and top and bottom of the fish body.

*See Glossary of New Stitches. 43

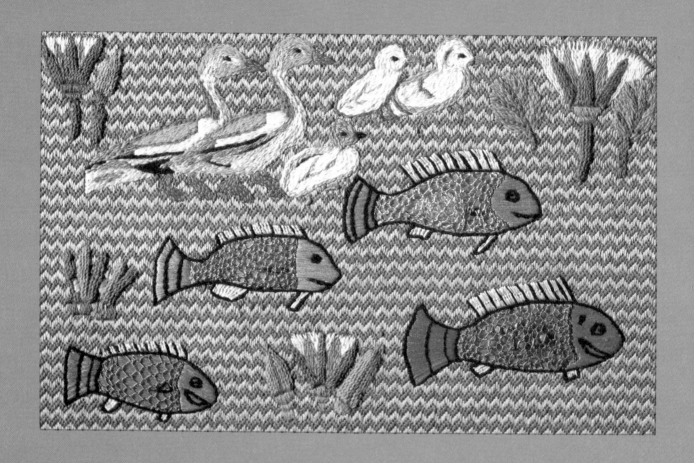

3. Head: Lay horizontal stitches on the head, using dark orange 6-strand cotton doubled, couching over the longest stitches several times with dark orange 6-strand cotton doubled. Work eye and mouth over the laid stitches, in Chain stitch (B), using 1 strand of black 6-strand cotton doubled.

4. Tail: Lay long stitches for the tail, fanning out slightly to follow contour of the tail, and using dark orange 6-strand cotton. Couch tail with two rows of Chain stitch (B), using black 6-strand cotton.

5. Fins: Work in long straight stitches, using gray 6-strand cotton and accenting with black 6-strand cotton. Couch across middle of upper fin with 1 strand of gray 6-strand cotton.

For colors of other fish see color illustration.

DUCKS AND DUCKLINGS

1. Work all ducks and ducklings in Split stitch (D).

2. Beak: Use dark orange 6-strand cotton doubled.

3. Head: Use 2 strands of medium turquoise wool, dividing center section with light taupe wool.

4. Body: Use black 6-strand cotton for the body markings, using 2 strands of the following colors of wool for the body: medium turquoise, dark turquoise, off-white taupe and medium taupe. See photo-pattern for approximate placement of colors.

5. Feet: Use dark orange 6-strand cotton doubled for the feet.
NOTE: The ducklings are worked in the same manner as the ducks, but using off-white taupe and medium taupe only for their bodies.

FLOWERS

1. Work the flower stems and calyx in Raised Stem stitch (E),* using 2 strands of dark yellow green wool. Work flower petals in encroached slanted Gobelin (F), using medium orange 6-strand cotton doubled, and 2 strands of white wool. For the tips of the petals use dark orange 6-strand cotton doubled. See color illustration.

2. Work the leaves in Chain stitch (B), using 2 strands of dark yellow green wool for the veins and 2 strands of medium yellow green wool for the leaf.

*See Glossary of New Stitches.

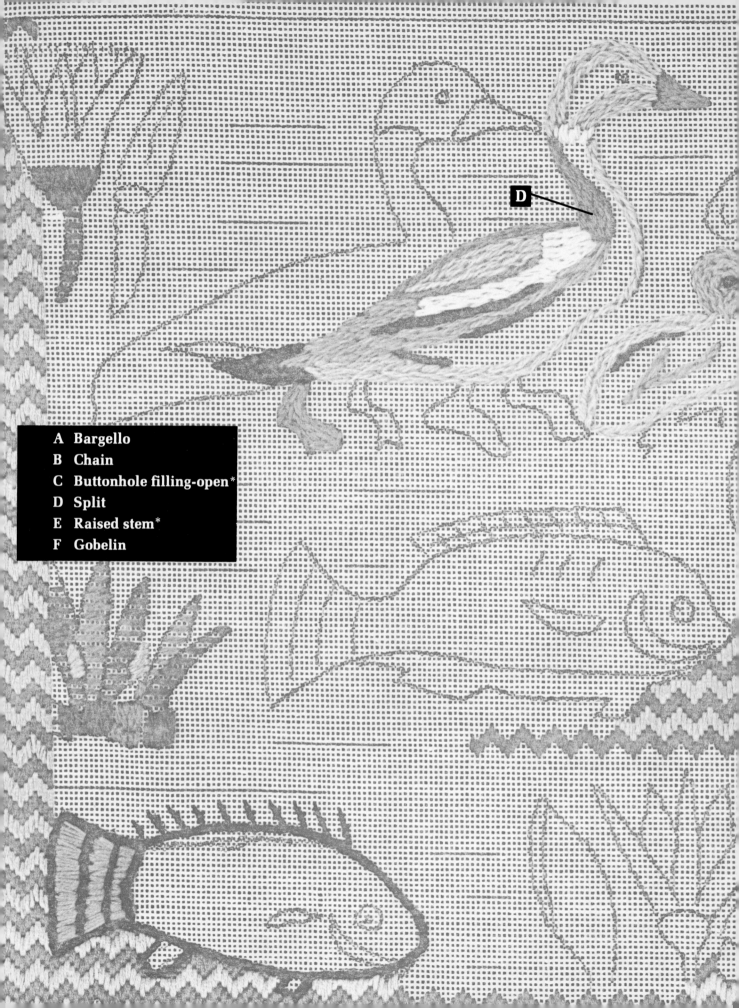

A Bargello
B Chain
C Buttonhole filling-open*
D Split
E Raised stem*
F Gobelin

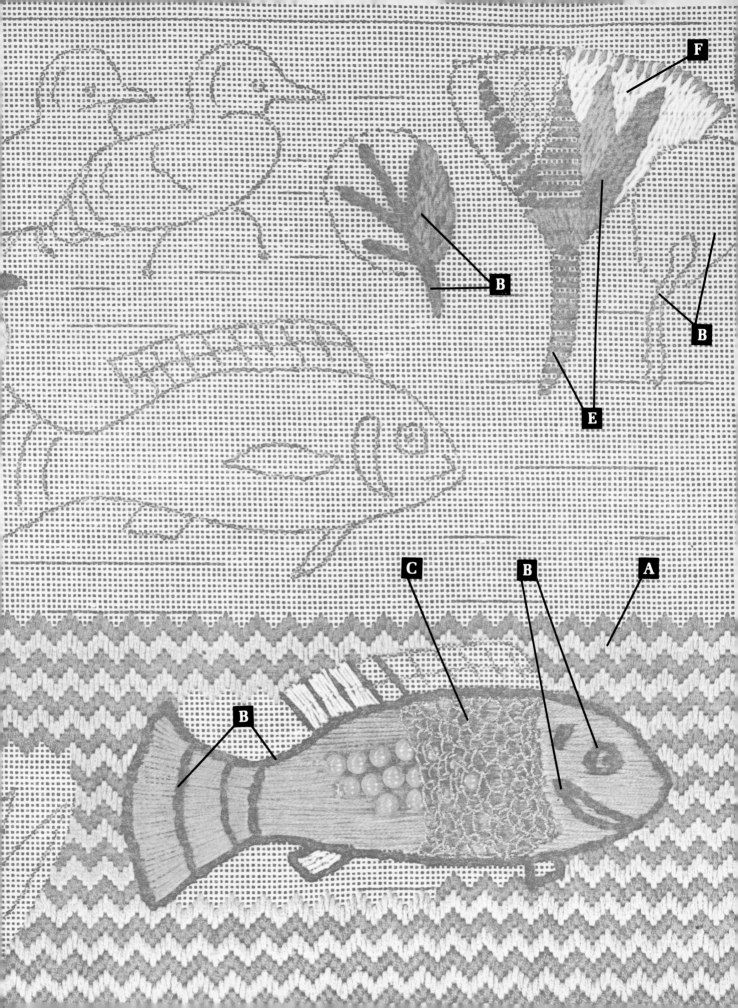

EGYPTIAN BORDERS

Border designs were found in profusion in Egyptian tombs. There are endless variations of geometric patterns, any of which could be used as borders around larger designs, as backgrounds, or as repeats for all-over areas for chair seats, bench covers and other household and personal articles. For this eyeglass case several colorful borders were joined together, as a sampler. Try your own combination of colors and patterns to make other design projects.

EGYPTIAN BORDERS IS DESIGNED TO BE USED AS AN EYEGLASS CASE, BOOK COVER, BELT, PICTURE FRAME OR SMALL PURSE.

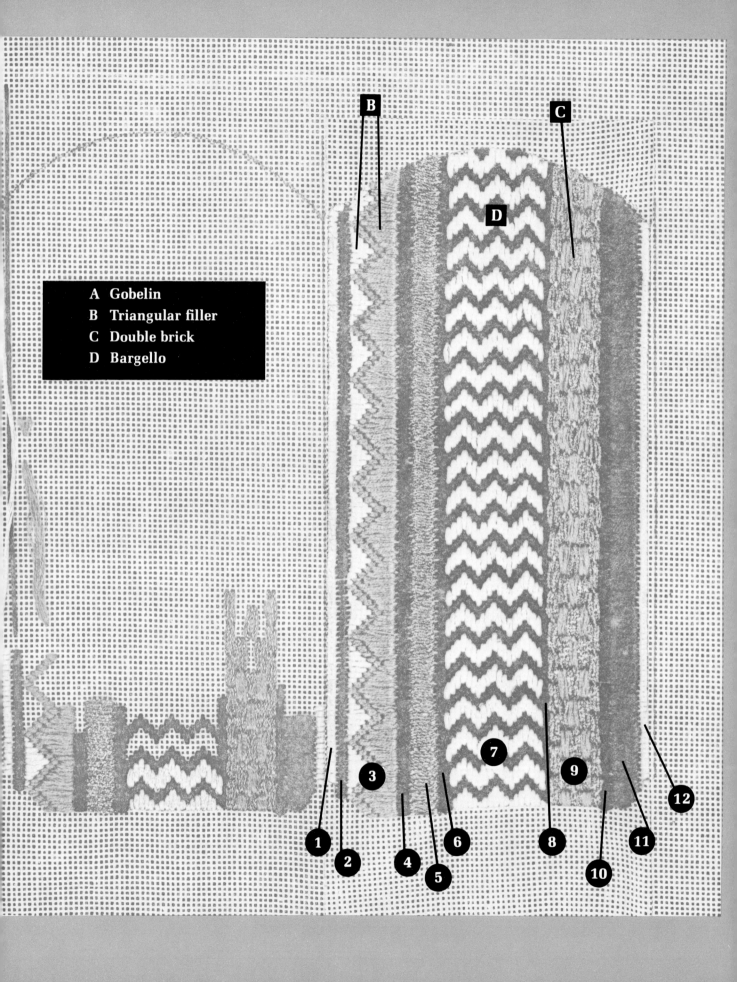

A Gobelin
B Triangular filler
C Double brick
D Bargello

INSTRUCTIONS

Canvas: 18-mesh white mono canvas (11″ x 11″)
Needle: no. 18 tapestry
Stretcher: 11″ x 11″
Finished size: 7″ x 7″ (case size is 3½″ x 7″)

Cotton threads	Other threads
bright blue (798)	gold metallic
light blue (800)	
dark blue (796)	
light gray (762)	
medium gray (415)	
dark gray (414)	
black DMC 6-strand Cotton	

Working the design

This pattern is best worked as a counted thread design. Prepare to work using the method described under General Directions. Follow photo-pattern for work sequence—numbers below correspond with numbers, on pattern. Gobelin (A) used throughout except where indicated.

1. Work in horizontal Gobelin (A) over 2 canvas threads, using light blue 6-strand cotton.

2. Work in horizontal Gobelin (A) over 2 canvas threads, using light gray 6-strand cotton.

3. Work in horizontal zigzag Gobelin (A) down center of Area 3. Work over 2 canvas threads, 6 stitches down to the right and then 6 stitches down to the left, using light gray 6-strand cotton. See photo-pattern. Fill to left of zigzag with Triangle Filler stitch (B), using medium gray 6-strand cotton. Fill to right of zigzag with Triangle Filler stitch (B), using dark blue 6-strand cotton.

4. Work in horizontal Gobelin (A) over 2 canvas threads, using black 6-strand cotton.

5. Work in horizontal Gobelin (A) over 6 canvas threads, using gold metallic.

6. Work in horizontal Gobelin (A) over 2 canvas threads, using black 6-strand cotton.

7. Alternate rows of black 6-strand cotton worked in Bargello (D) in 2-1 step. The next row is 3-1 step using light blue and black.

8. Work in horizontal Gobelin (A) over 2 canvas threads, using black 6-strand cotton.

9. Work in Double Brick stitch (C) vertically over 6 canvas threads, alternating double strands of gold metallic with bright blue 6-strand cotton, double.

10. Work in horizontal Gobelin (A) over 2 canvas threads using black 6-strand cotton.

11. Work in horizontal Gobelin (A) over 6 canvas threads, using dark gray 6-strand cotton.

12. For the spine of the case: Work in horizontal Gobelin (A) over 2 canvas threads, using light blue 6-strand cotton.

Working the repeat

Repeat steps, beginning with 12 and working backward to 1.
NOTE: When vertical stitches meet horizontal stitches canvas will show through. To cover this, work a Back stitch between these two areas.

ISIS KNEELING

From the Tomb of Amenhotep II comes the inspiration for this rich rendering of the deity Isis. Greatest of all Egyptian goddesses, she was the most popular of the female deities mainly because of her ability to protect children, and also because she was the personification of the loyal wife and devoted mother.

Following the custom among royalty in Egypt at this time, as well as among the worshipped deities, Isis was both wife and sister to the god-king Osiris. Together with their son Horus they were the symbol of the perfect family.

This beautifully designed piece uses gold metallic thread for Isis's dress, the focal point of the needle painting. The interesting border designs on either side could also be used as separate decorative devices, or incorporated into other projects. On the background is seen another lovely new lacy stitch—fittingly named the Isis stitch.

ISIS KNEELING IS DESIGNED TO BE USED AS A SCRAPBOOK OR CORRESPONDENCE FOLDER.

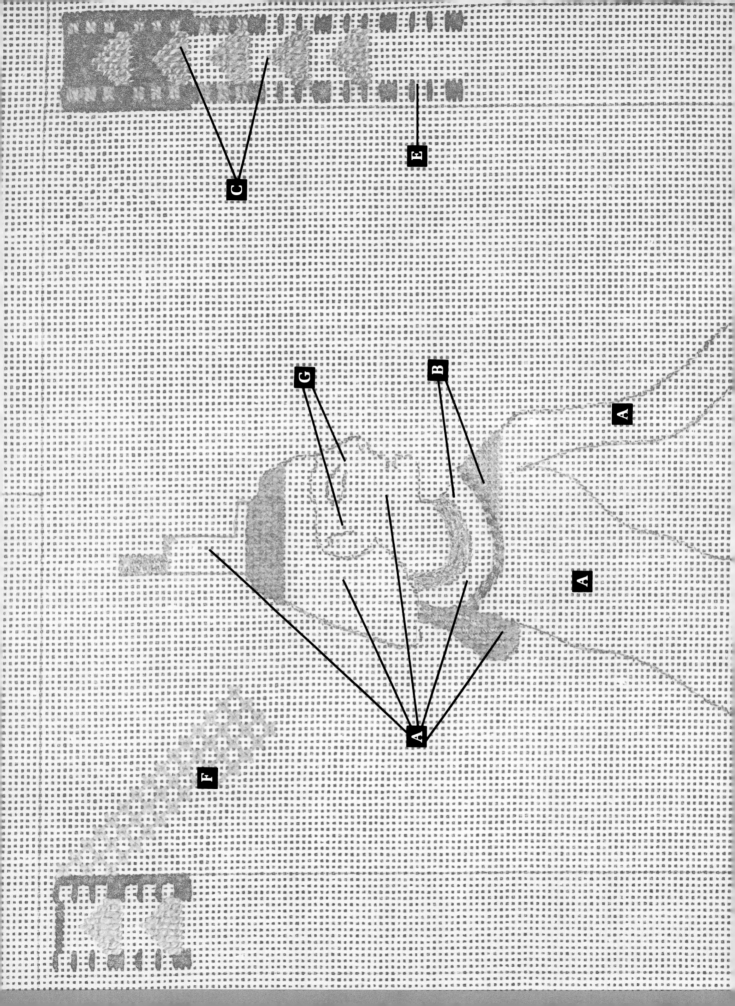

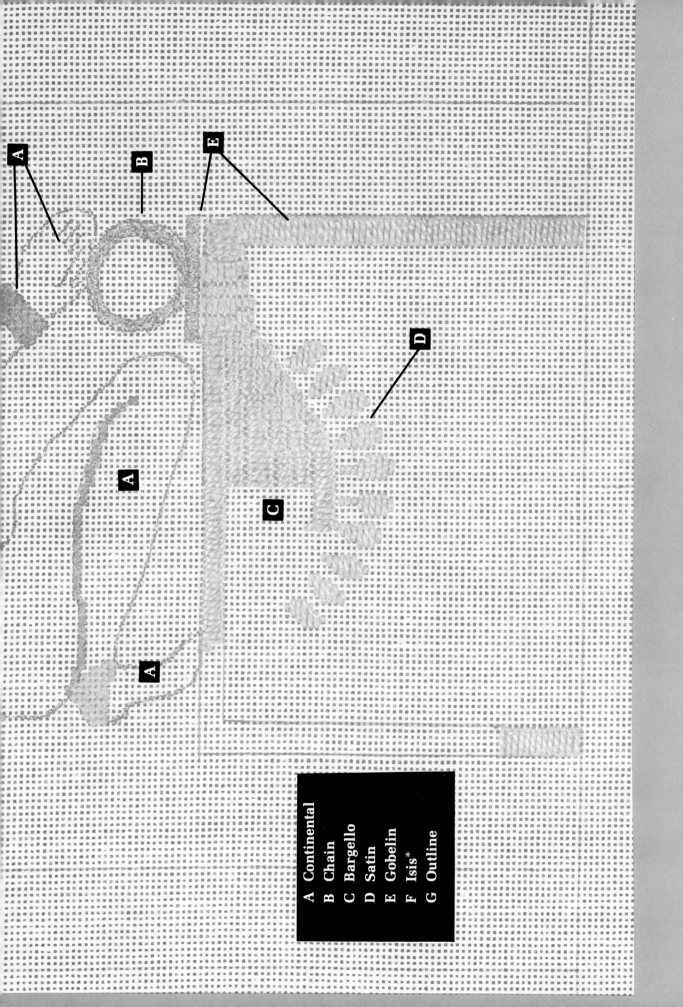

A Continental
B Chain
C Bargello
D Satin
E Gobelin
F Isis*
G Outline

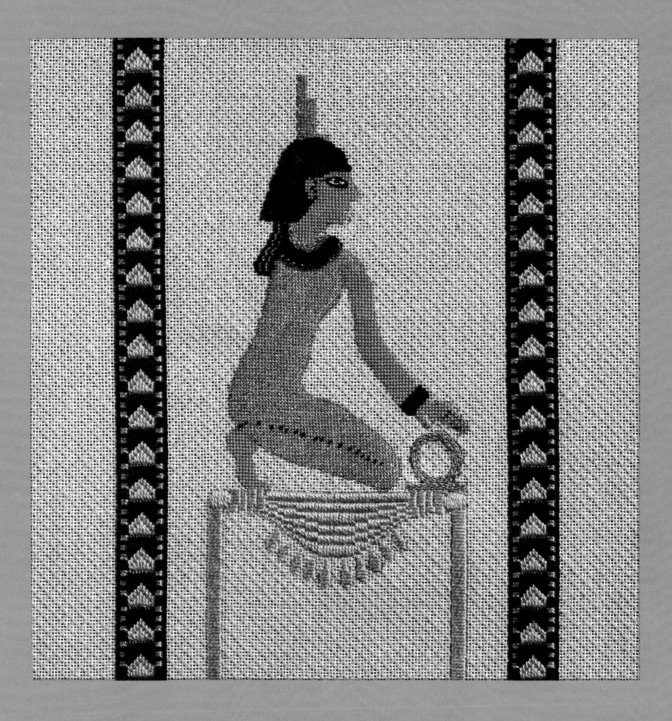

INSTRUCTIONS

Canvas: 16-mesh white mono canvas (18″ x 18″)
Needle: no. 18 tapestry
Stretcher: 18″ x 18″
Finished size: 14″ x 14″

Persian wool
light turquoise (748)
 or turquoise Marlitt (1218)

Other threads
DMC Pearl Cotton no. 3
 black
 white
 gold (729)
 dark flesh DMC 6-strand
 cotton (436)
 gold metallic

Working the design.

Transfer center design and mark lines for borders. Prepare to work, using the method described under General Directions.

FIGURE OF ISIS

1. Dress: Outline and fill in dress in Continental (A), using gold metallic.

2. Head ornament: Outline and fill in Continental (A), using gold metallic.

3. Necklace: Work a double row of Chain stitch (B) for top part of necklace, using gold metallic. Work a single row of Chain stitch (B), using gold metallic whipped over with black Pearl Cotton, for bottom of necklace. Work area between these rows of Chain stitch in Continental (A), using black Pearl Cotton.

4. Wristband: Outline and fill in Continental (A), using black Pearl Cotton.

5. Hair: Outline and fill in Continental (A), using black Pearl Cotton.

6. Ponytail: Outline in Continental (A), using black Pearl Cotton. Work two rows of Continental (A) in gold metallic inside the ponytail. See color illustration. Fill in with black Pearl Cotton in Continental.

7. Face, arm, hand and feet: Outline and fill in Continental (A), using dark flesh 6-strand cotton. Details of face and eye are worked in small

Outline stitches (G) using black Pearl Cotton. Center of eye is filled with white Pearl Cotton.

8. Symbol: Outline circle in Chain stitch (B), using gold metallic. Work base in vertical Gobelin (E), again using gold metallic.

GOLDEN TABLE

Work in Bargello (C) and Satin stitch (D), using gold Pearl Cotton. See photo-pattern for arrangement of stitches and thread count. Work legs of table in horizontal Gobelin (E), using gold Pearl Cotton.

Working the border

The borders are worked over 14 canvas threads. First work the center triangular designs in Bargello (C), using gold Pearl Cotton. See photo-pattern for thread count. Work the gold stitches on the sides of the border design in horizontal Gobelin (E) over 3 canvas threads, using gold Pearl Cotton. Fill in between these gold lines with black Pearl Cotton worked in horizontal Gobelin (E). Last, work the border background in Bargello (C), using black Pearl Cotton. Extend the background stitch beyond border to completed size. See color illustration for added clarity.

Working the background

Work the background in the Isis stitch (F),* using 1 strand of light turquoise wool, or use light turquoise silk for an even more lustrous effect.

*See Glossary of New Stitches.

58

NEFERTITI

The beautiful Queen Nefertiti was King Tutankhamun's mother-in-law. She never occupied the throne of Egypt, but was very influential in the country's history through her marriage to King Akhenaton, the heretic king, and her likeness is often seen in statues and bas-reliefs. Nefertiti's beauty, more than her royal station, made her a favorite subject for artists of the day. The most famous portrait of any woman of ancient times is the painted limestone bust of the queen which has been adapted for this needle painting. The head is believed to have been part of a composite statue, the figure probably made of some other material and designed so that the head could be attached at the shoulders. The eyes of the regal head are inlaid, one of the reasons we suspect it was a part of a whole statue, and not merely a bust.

Although this striking piece reproduces the original sculpture as a painting, the details of the headdress are so outstanding that the motif could easily be used for an over-all design.

NEFERTITI IS DESIGNED TO BE USED AS A WALL HANGING, PILLOW OR ALBUM COVER.

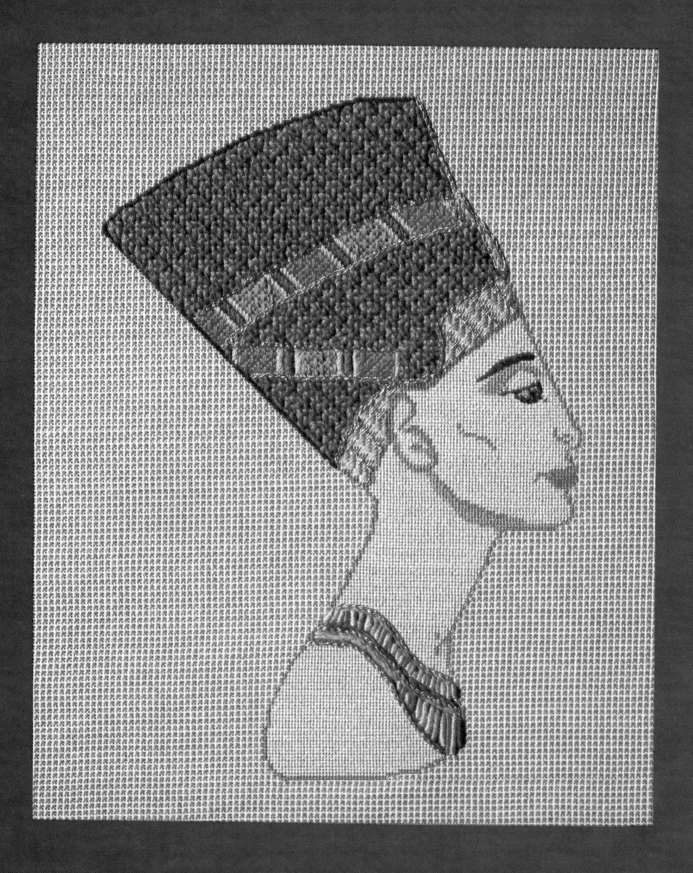

INSTRUCTIONS

Canvas: 18-mesh white mono canvas (15″ x 19″)
Needle: no. 18 tapestry
Stretcher: 15″ x 19″
Finished size: 11″ x 15″

Threads
DMC 6-strand cotton

gold (729)
red (350)
medium green (911)
navy (824)
medium blue (825)
light aqua (932)

turquoise (995)
medium brown (976)
rosy beige (437)
medium rosy beige (436)
dark rosy beige (435)
flesh (738)

Other threads
gold metallic

Working the design

Trace the head and shoulders of Nefertiti and prepare to work, using method described under General Directions.

1. Outline the face, neck, shoulder and lower edge of headdress in Continental (A), using medium brown 6-strand cotton.

2. Outline ear, jawline, crease line of eyelid, cheek line, mouth and other dark lines of face in Continental (A), using medium brown 6-strand cotton.

3. Eye and eyebrow: Outline in Chain stitch (B), using navy 6-strand cotton. Work Iris in Continental (A), using light aqua 6-strand cotton. For the white of the eye work in Continental (A), using flesh 6-strand cotton.

4. Under brow and under jawline: Work in Continental (A), using medium rosy beige 6-strand cotton.

5. Mouth: Fill in with Continental (A), using dark rosy beige 6-strand cotton.

Working the headdress

1. Work the outlines and areas using metallic threads next. Outline front of headdress, top of headband, and edges of jeweled bands in Chain stitch (B), using gold metallic.

61

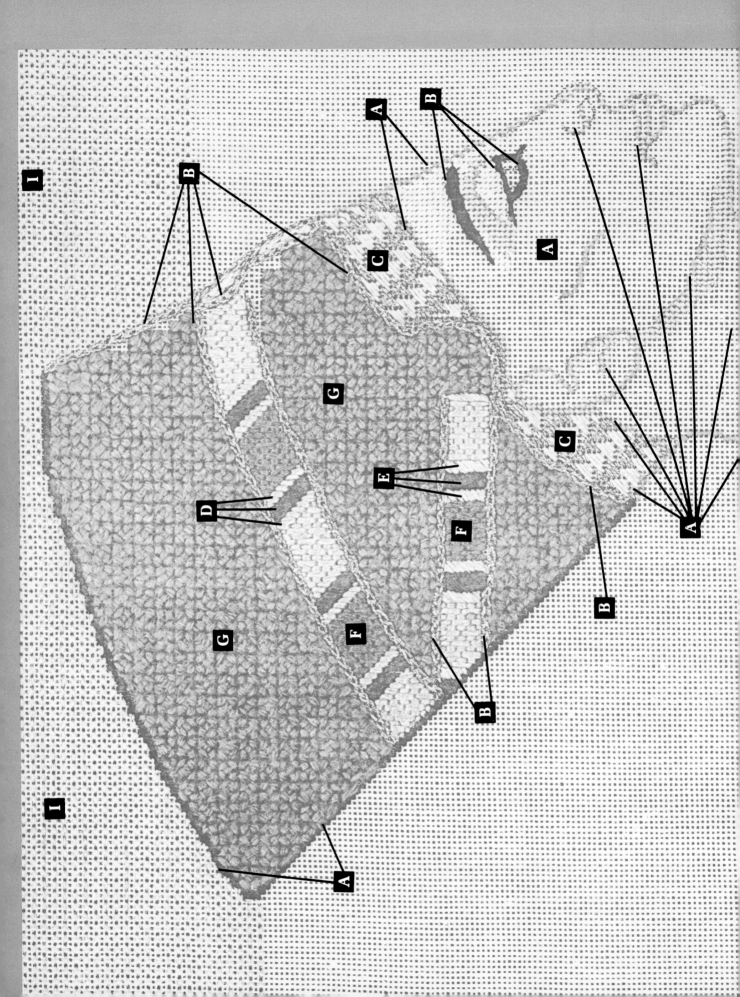

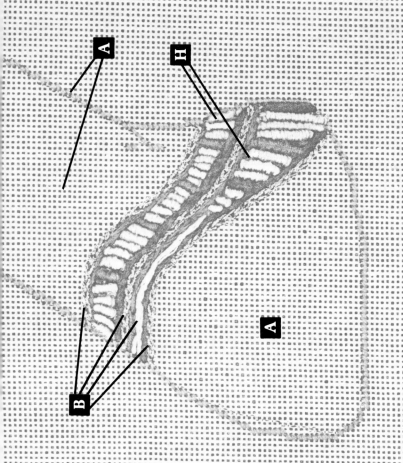

A Continental
B Chain
C Milanese
D Florentine
E Gobelin
F Hungarian
G Flower rice*
H Bullion
I Filigree*

2. Gold headband: Work in Milanese stitch (C), alternating lines of gold metallic (work first) with gold 6-strand cotton.

3. Outline top and back of headdress in Continental (A), using navy 6-strand cotton.

4. Work stripes in jeweled bands in Florentine stitch (D), using gold 6-strand cotton over 3 canvas threads for the narrow stripe and navy 6-strand cotton over 4 canvas threads for the wider stripe.
NOTE: In lower band the stripes are worked in slanted Gobelin (E). See photo-pattern for direction of stitches.

5. Work wide areas of color in Hungarian stitch (F), alternating red and green 6-strand cotton.

6. Background of headdress is worked in Flower Rice stitch (G),* using navy 6-strand cotton for the basic stitch and medium blue for the over-stitch. (Cover every second cross with medium blue. This is shown in the Glossary of New Stitches.)

Working the necklace

1. Outline top, bottom and middle rows of necklace in Chain stitch (B), using gold metallic.

2. Top row of jewels: Work in Bullions (H), using navy, gold, turquoise, red and green 6-strand cotton. Alternate colors. See color illustration.

3. Bottom row of jewels: Work in Bullions (H), using navy, gold, red, gold, green gold, turquoise 6-strand cotton. Alternate colors. See color illustration. Where row narrows, work in Chain stitch (B), using gold 6-strand cotton.

4. Work a Compensation stitch, using navy 6-strand cotton between rows of colored Bullions and gold metallic outlines.
Fill in the unworked areas of the face, neck and shoulder in Continental (A), using rosy beige 6-strand cotton.

Working the background
Work in Filigree stitch (I),* using light aqua 6-strand cotton.

*See Glossary of New Stitches.

Archaeological excavation in Egypt began during the late
eighteenth century, but it was not until the discovery of the
magnificent tomb of the young Pharaoh Tutankhamun in
1922 that the entire world became aware of the wealth and
beauty that were part of that ancient civilization.

The tomb, though occasionally disturbed by vandals, is the
only one ever found to be so complete—the mummy of the
seventeen-year-old king was undisturbed, and all but a few
of the buried objects were intact.

The dazzling treasures of the tomb have been a source of
inspiration for artists and artisans for years, and on the
following pages are presented an exciting collection of
needlework adaptations for the craftsmen of today.

PART II

KING TUTANKHAMUN

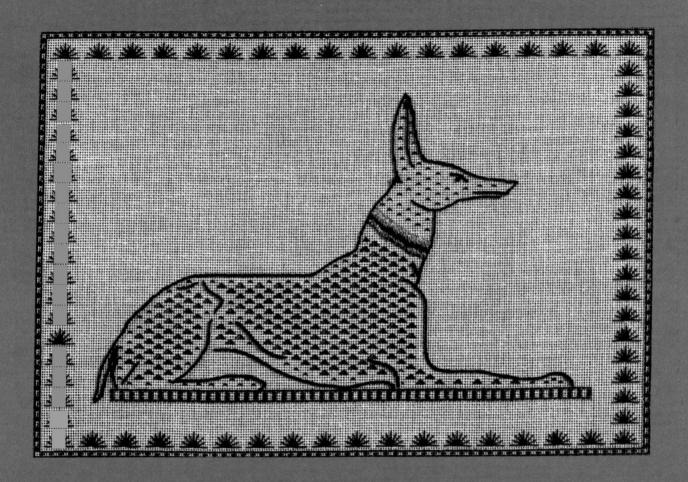

ANUBIS

The Anubis was the patron of the art of embalming and protector of the burial chamber. This imaginary animal was always black, the color not of mourning but of rebirth. A beautiful example of this sentinel, carved in wood and covered with black resin, was found guarding the entrance to the burial chamber of King Tutankhamun's tomb.

This piece, inspired by that figure, introduces two new stitches—the Pyramid stitch used for the animal (a Double Pyramid stitch is used for the body and a Single Pyramid stitch for the head), and the Papyrus stitch used in the border design.

THE ANUBIS IS DESIGNED TO BE USED AS A WALL HANGING, TRAY INSERT, PILLOW OR TOTEBAG.

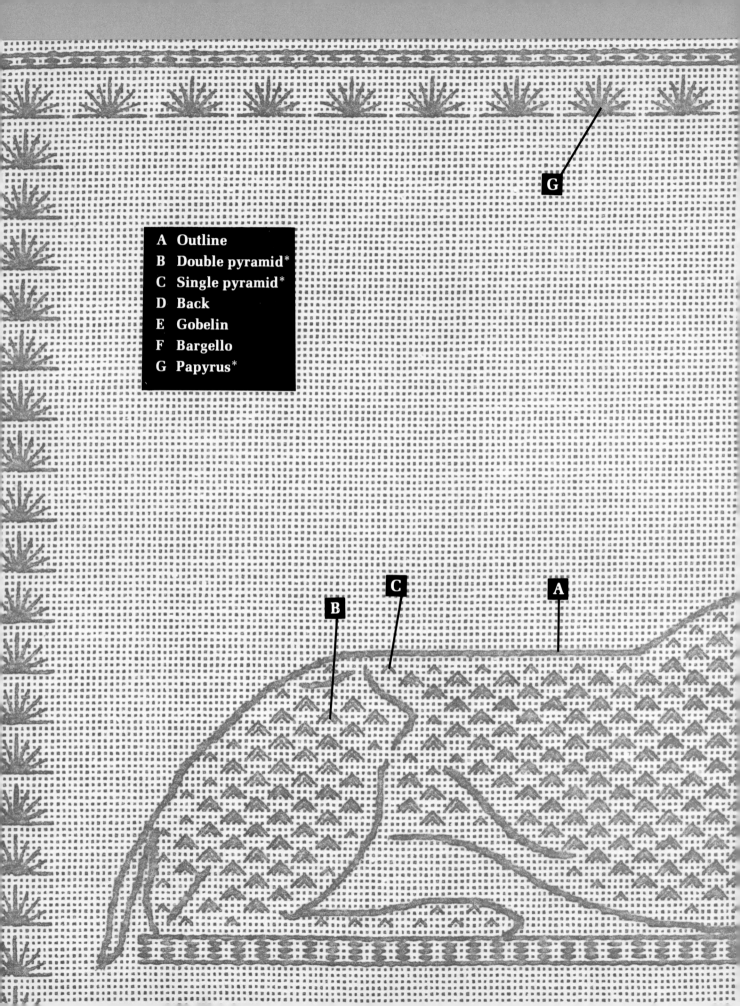

A Outline
B Double pyramid*
C Single pyramid*
D Back
E Gobelin
F Bargello
G Papyrus*

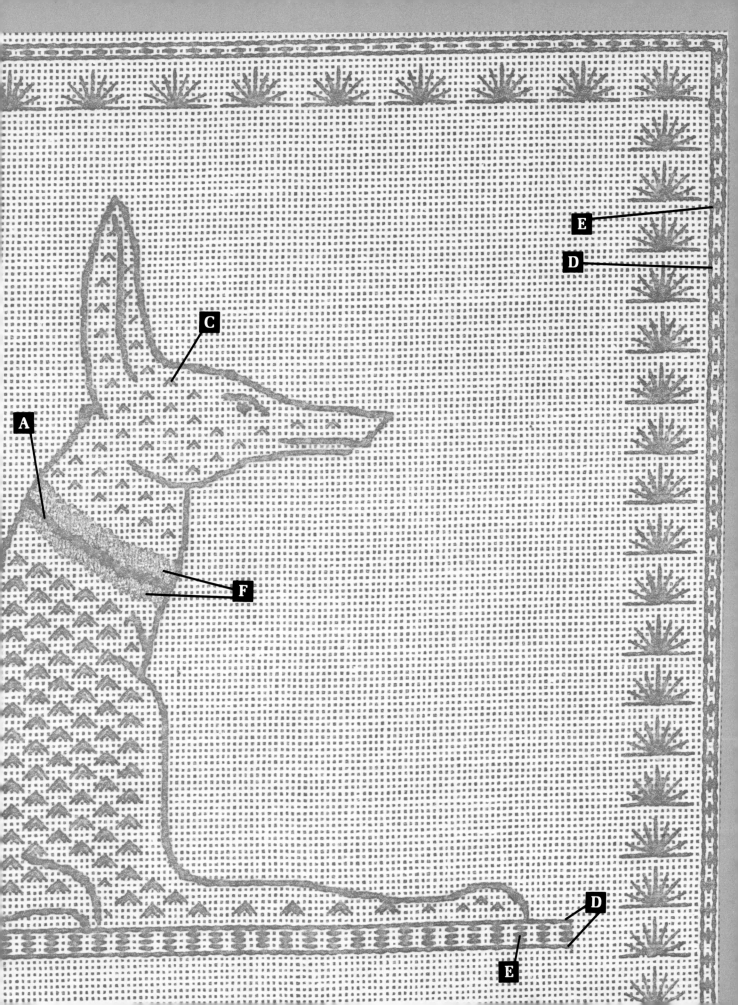

INSTRUCTIONS

Canvas: 16-mesh white mono canvas (20" x 16")
Needle: no. 18 tapestry
Stretcher: 20" x 16"
Finished size: 16½" x 11"

Threads
black DMC 6-strand cotton
gold metallic

Working the design

Transfer the design and prepare to work, using the method described under General Directions.

NOTE: Begin and end threads with care so they will not show through the unworked canvas. If thread ends show it will detract from the airy feeling of the background.

1. Body: Outline the body and inside lines of the figure with Outline stitch (A), using full ply of black 6-strand cotton. Fill the body with a Double Pyramid stitch (B),* and fill in small areas of body with Single Pyramid stitches (C),* using only 3 strands of black 6-strand cotton. See photo-pattern for approximate placement of stitches.

2. Head: Fill the head with the Single Pyramid stitch (C),* again using only 3 strands of black 6-strand cotton. See photo-pattern for approximate placement of stitches.

3. Base of figure: Beginning at right side of base, work series of 5 vertical Back stitches (D) over 2 canvas threads using full ply of black 6-strand cotton. Skip 2 canvas threads between each group except for the top and bottom line where a Back stitch (D) is worked making a continuous line. See photo-pattern.

4. Gold Collar: Work top of collar in vertical Bargello (F), using a double thread of gold metallic and working over 4 canvas threads. Drop down 1 mesh and work bottom of collar, again using double thread of gold metallic and working in vertical Bargello (F); this time, however, working over only 2 canvas threads. Fill free mesh between rows of gold metallic threads with Outline stitch (A), using full ply of the black 6-strand cotton.

Working the border

1. Work top border in Papyrus stitch (G),* using 2 strands of black 6-strand cotton. See photo-pattern for exact placement and number of stitches. Count up 14 canvas threads from tip of Anubis's ear and place first Papyrus stitch.

2. Work side borders.

3. Work bottom border. The bottom border is not shown on photo-pattern, but there should be one more horizontal row of Papyrus and a frame with spacing done as for top border (14 canvas threads below base of figure). See color illustration.

4. Work frame of border by placing Back stitches (D) and Gobelin (E) as shown on photo-pattern, being careful in drawing the thread behind the canvas so that it does not show through from the right side.

*See Glossary of New Stitches.

DESERT IBEX

A small ebony throne was found in King Tutankhamun's tomb, the size indicating the chair was made for the king when he was a child. It is inlaid with ivory and two gold covered wooden panels are set into the arms. One of the panels shows a desert animal, the Ibex, perhaps felled by the young ruler with a dart, attesting to his ability as a hunter.

This panel has been adapted into a needlework design of fragile beauty, and its delicacy calls for special stitches. Two new ones were created for the panel, the Dart stitch and the Ibex stitch. The Half-cross Skip stitch used for the lacy background is also a new stitch, and is seen in other pieces in the book.

THE DESERT IBEX IS DESIGNED TO BE USED AS A WALL HANG-ING, PILLOW OR TRAY INSERT.

INSTRUCTIONS

Canvas: 16-mesh white mono canvas (22″ x 16″)
Needle: no. 18 tapestry
Stretcher: 22″ x 16″
Finished Size: 17½″ x 12″

Threads
white DMC Pearl Cotton no. 3
gold DMC 6-strand cotton

Working the design

Transfer the design and prepare to work, using the method described under General Directions. Use a gray marking pen, as black will show through the light threads.

1. Outline the Ibex and branch in Chain stitch (A), using white Pearl Cotton.

2. Work the other lines of the Ibex in Chain stitch (A), using white Pearl Cotton. See photo-pattern for approximate placement of lines.

3. Fill in the head of the Ibex with the Dart stitch (B),* using white Pearl Cotton.

4. Fill in the body of the Ibex with the Ibex stitch (C),* using white Pearl Cotton.

Working the border

Begin the border design at the bottom. See photo-pattern. Work toward the corners.

1. Work in Bargello (D) over 4 canvas threads, using white Pearl Cotton.

2. Work bottom border to match top.

3. Work the side borders, matching right side of design to left side, and using photo-pattern as a guide.

4. Work the frame in straight Gobelin over 4 canvas threads. Use white Pearl Cotton. See color photo for placement of outer frame.

*See Glossary of New Stitches

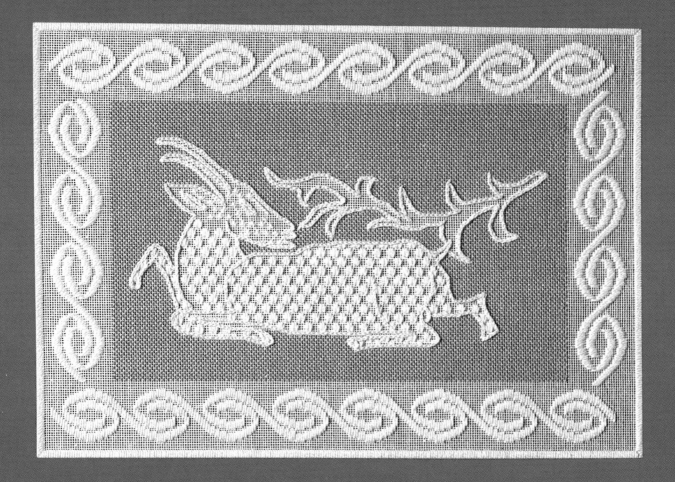

Working the background

Work in Half-cross Skip stitch (E),* using 3 strands of gold 6-strand cotton. Gold Pearl Cotton may be used instead of 6-strand cotton, if desired. Leave 3 free canvas threads between the background and the border design.

NOTE: Start new threads at the beginning or end of a line for a neat appearance on the front of the canvas.

*See Glossary of New Stitches.

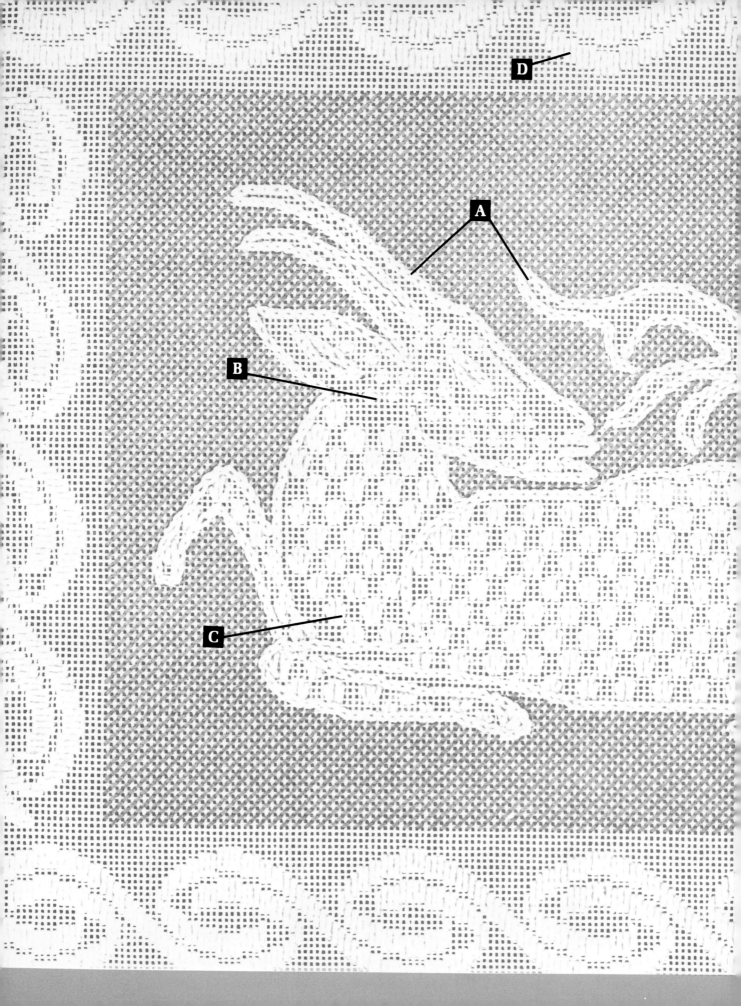

A Chain
B Dart*
C Ibex*
D Bargello
E Half-cross skip*

E

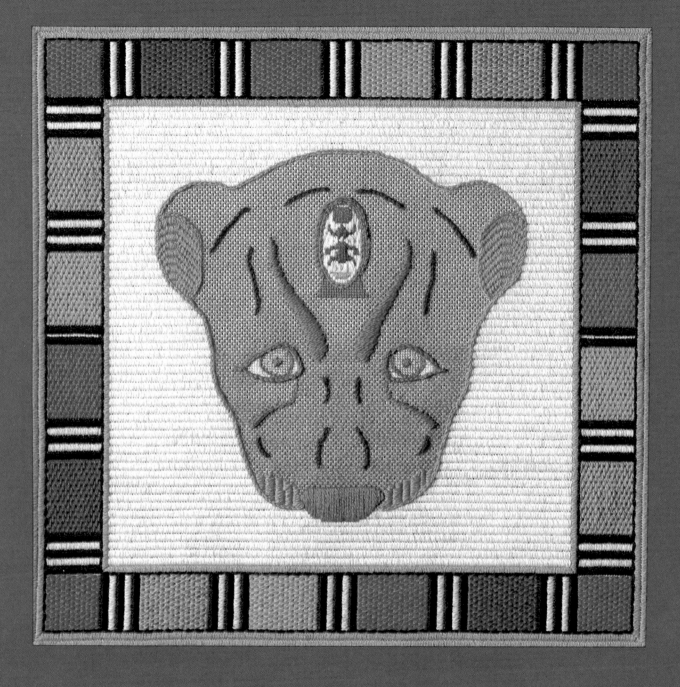

ROYAL
LEOPARD

*The leopard head was found in the Tomb of King
Tutankhamun, fastened to an actual leopard skin. The
animal was a symbol of the king's role as priest, and this
one was beautifully carved from wood, overlaid with gold,
and inlaid with colored glass. The cartouche in the center
of the leopard's forehead spells King Tutankhamun's
throne name, using the hieroglyphic symbols of the sun's
disc, a beetle underlined with triple strokes, and a basket.*

THE ROYAL LEOPARD IS DESIGNED TO BE USED AS A PILLOW,
WALL HANGING, CHAIR SEAT OR TOTEBAG.

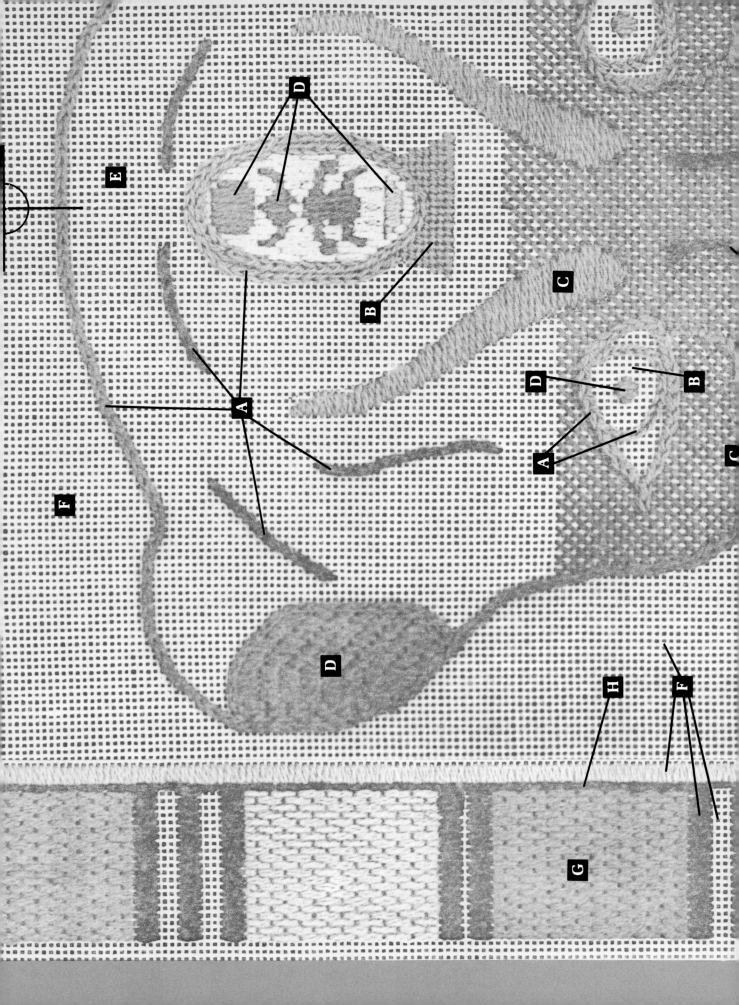

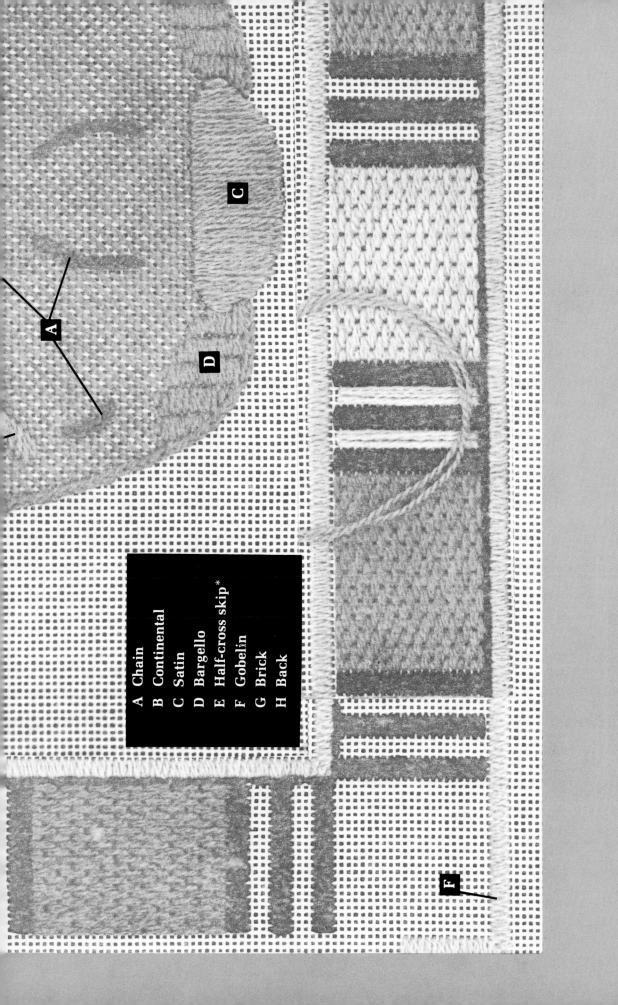

A Chain
B Continental
C Satin
D Bargello
E Half-cross skip*
F Gobelin
G Brick
H Back

INSTRUCTIONS

Canvas: 14-mesh white mono canvas (21″ x 21″)
Needles: no. 20 tapestry for wool threads
　　　　　no. 18 tapestry for cotton and silk threads
Stretcher: 21″ x 21″
Finished size: 17½″ x 17½″

Persian wool	*Other threads*
brown (154)	black DMC Pearl Cotton no. 3
off-white (040)	chartreuse silk
dark gold (427)	
light gold (445)	
dark coral (843)	
dark blue (742)	
medium blue (752)	
turquoise (783)	

Working the head

Transfer the center design and prepare to work, using the method described under General Directions.

1. Head: Outline in Chain stitch (A), using 2 strands of dark gold wool.

2. Eyes: Outline in Chain stitch (A), using 2 strands of medium blue wool. Outline the iris in Chain stitch (A), using 1 strand of medium blue wool, then fill the iris in Continental (B), using chartreuse silk doubled. Work the pupil in vertical and horizontal Bargello (D), using 1 strand of medium blue wool. Work the white of the eye in Continental (B), using 2 strands of off-white wool.

3. Eyebrows and cheek lines: Using photo-pattern as a guide, work in horizontal Satin stitch (C), using 3 strands of medium blue wool.

4. Nose: Work in vertical Satin stitch (C), using 3 strands of medium blue wool.

5. Moustache and inside of ear: Work ear in vertical and moustache in horizontal Bargello (D), using 2 strands of dark gold wool. The stitches are worked freeform to follow contours.

6. Cartouche: Outline the frame with 2 rows of Chain stitch (A), using 2 strands of medium blue wool. Work base in Continental (B), using 2

strands of medium blue wool. Work hieroglyphic symbols in Bargello (D), using the following colors:

Sun—2 strands of dark coral wool
Scarab—2 strands of dark blue wool
Triple strokes and basket—2 strands of turquoise wool
Background—2 strands of off-white wool

7. Background of leopard's head: Work in Half-cross Skip stitch (E),* using 3 strands of dark gold wool.

8. Other lines in face: Work in Chain stitch (A), using 2 strands of brown wool. See photo-pattern for placement of lines.

Working the border

Begin at the top center of the design, first working the multicolored border portion and then the turquoise inner and outer frame portions.

1. Top and bottom: Work dark bars in horizontal Gobelin (F) over 3 canvas threads, using black Pearl Cotton doubled. Work toward corners skipping 3 canvas threads in the two spaces between the 3 dark bars. Refer to photo-pattern for placement of 3-bar groups.

2. Colored blocks of border: Fill in with 7 horizontal Brick stitches (G), over 4 threads using 2 strands of wool and alternating colors as depicted. NOTE: Corner blocks are *only* 5½ horizontal Brick stitches. For bottom border—reverse the order. See color illustration.

3. Sides: Work in the same manner as for the top and bottom, but use vertical Gobelin and Brick stitches and refer to color illustration for order of multicolored portions.
NOTE: At the center of each side border there are only 2 dark bars instead of the 3 used on the top and bottom, and only 1 canvas thread is skipped between these 2 dark bars.

4. Light colored bars: For the top and bottom work in horizontal Gobelin (F), and for the sides work in vertical Gobelin (F), both over 3 canvas threads, using 3 strands of off-white wool.

5. Frame: Work inside and outside around completed multicolored portion in Gobelin (F) over 3 canvas threads, using 2 strands of turquoise wool. Work 1 row for the inner frame and 2 rows for the outer frame, then miter the corners.

*See Glossary of New Stitches.

6. Finishing frame: Work a row of Back stitch (H) over 4 canvas threads between the rows of the turquoise inner and outer frames of the multi-colored portion of the border design, using black Pearl Cotton. This row will cover the canvas which shows through where the vertical and horizontal threads of the border meet.

Working the background

Work in vertical Gobelin (F) over 3 canvas threads, using 2 strands of off-white wool or, as an alternative, work in Diagonal Tent or Basket Weave, using 2 strands of the off-white wool.

LOTUS
AND BUDS

It is written in the Egyptian Book of the Dead that jeweled collars, with elaborate pectorals in the front and "mankhets" or tags hanging down the back, be placed around the neck of the deceased. These mankhets were somewhat simpler in design than the front pieces, though they were equally as beautiful.

The inspiration for this group of lotus flowers and buds came from the front piece of one of these neck ornaments. Made of gold, cloisonné, turquoise, and lapis lazuli, it is one of the most ornate treasures found in King Tutankhamun's tomb. The design is stylized and lends itself to the bold rendering given to it. Inspiration for the delicate cloisonné evening bag following Lotus and Buds came from the mankhet of this same necklace.

LOTUS AND BUDS IS DESIGNED TO BE USED AS A BENCH COVER, PILLOW, WALL HANGING, TRAY OR RUG.

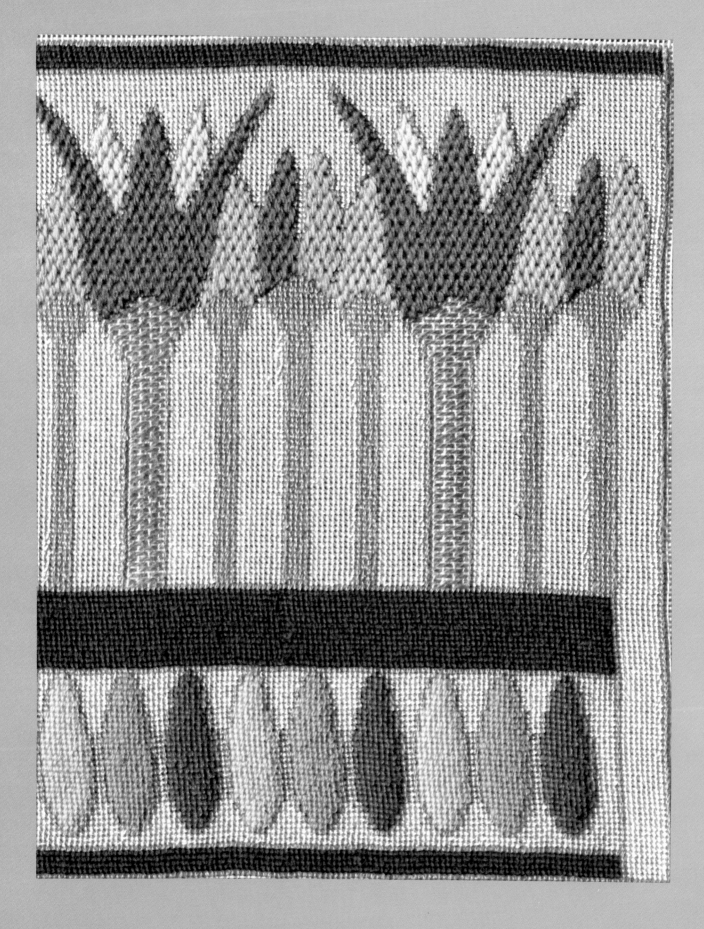

INSTRUCTIONS

Canvas: 14-mesh white mono canvas (24″ x 15″)
Needle: no. 18 tapestry
Stretcher: 24″ x 15″
Finished size: 21″ x 11½″

Persian wool	*Other threads*

Persian wool
1. dark turquoise (750)
2. medium dark turquoise (755)
3. medium turquoise (760)
4. light turquoise (765)
5. dark blue (310)
6. aqua (783)

Other threads
7. gold DMC Pearl Cotton no. 3 (729)
8. light blue-green Marlitt silk (1052)
 or substitute Pearl Cotton no. 3 (747)

NOTE: *Color numbers indicate numerals on photo-pattern.*

Working the design

Prepare to work using the method described under General Directions. The stitches in this design should be counted from the photo-pattern or a graph may be made to use as a pattern.

1. Outline flowers, buds, ovals and bands in Continental (A), using gold Pearl Cotton.

2. Ovals: Work in Continental (A), using 2 strands of the light, medium and dark shades of turquoise wool. Alternate these three shades across the bottom of the design, beginning and ending with a dark oval.

3. Flowers and buds: Work in Brick stitch (B) over 4 canvas threads, using 2 strands of wool in the colors keyed above. See color illustration.

4. Stems of flowers: Work in Brick Filling stitch (C) over 4 canvas threads, using gold Pearl Cotton.

5. Stems of buds: Work in Continental (A), using gold Pearl Cotton.

6. Dark bands: Work in Continental (A), using 2 strands of dark blue wool.

Working the background

Work in Diagonal Tent stitch (D), using light blue-green silk doubled or as an alternative, light blue-green Pearl Cotton.
NOTE: The piece would make a very attractive rug. To expand the design, use the pattern twice (have the flowers facing away from each other) and lengthen. Use a third row of ovals separated by a wide dark blue stripe for the center of the rug.

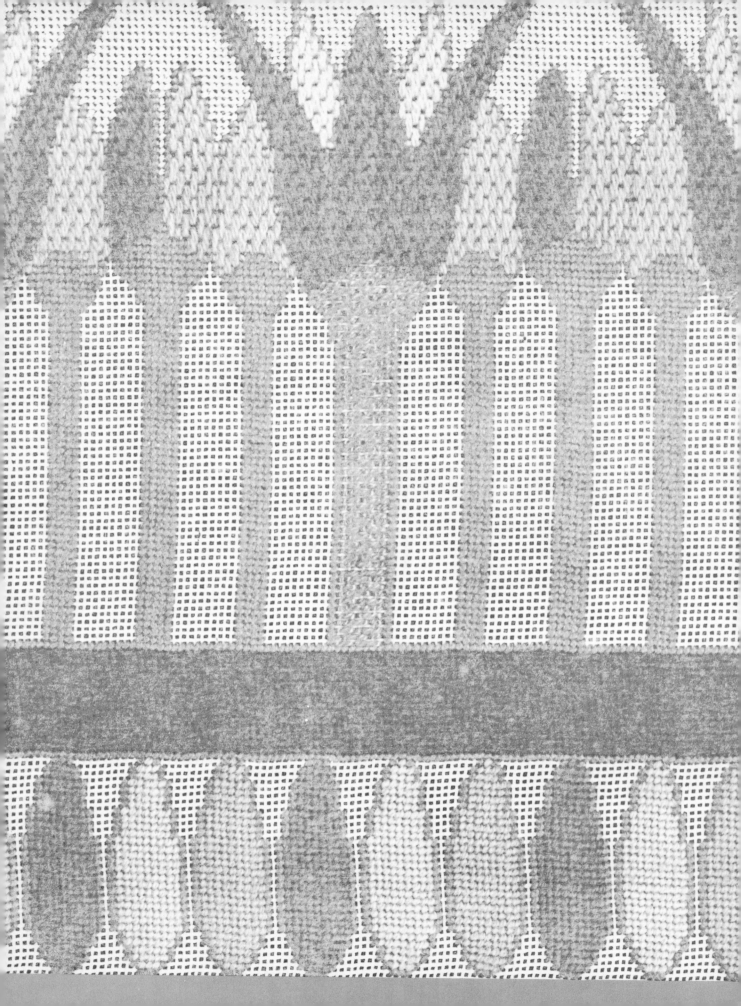

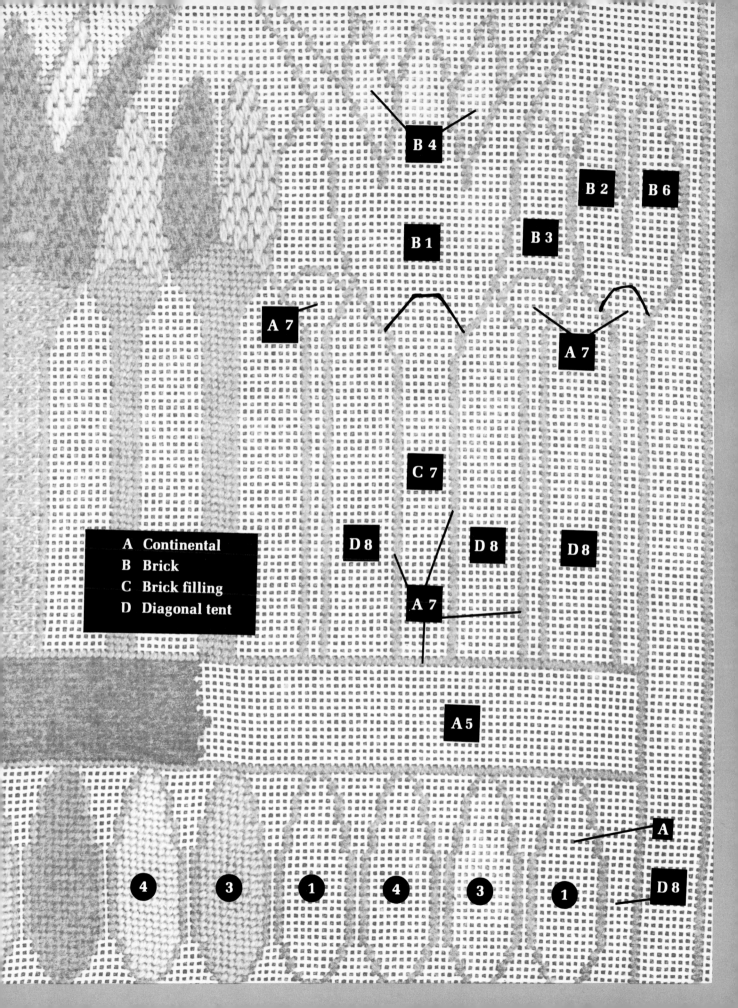

B 4

B 2 B 6

B 1 B 3

A 7 A 7

C 7

D 8 D 8 D 8

A Continental
B Brick
C Brick filling
D Diagonal tent

A 7

A 5

A

4 3 1 4 3 1 D 8

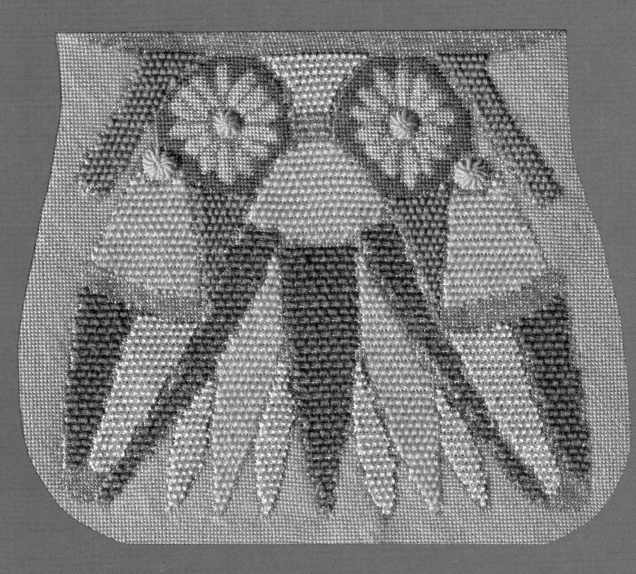

CLOISONNÉ LOTUS

The petals and buds of the blue lotus were fashioned into the heavy tassels of one of the richest treasures uncovered in King Tutankhamun's tomb, a beautiful gold and cloisonné pectoral. Worked in gold metallic and cotton threads to simulate lapis lazuli and semiprecious stones, this handsome evening bag is adapted from that tassel design of exquisite artistry.

THE CLOISONNÉ LOTUS IS DESIGNED TO BE USED AS AN EVENING BAG, PILLOW OR ALBUM COVER.

A Continental
B Diagonal tent
C Whipped spider web
D Single couched
E Double couched

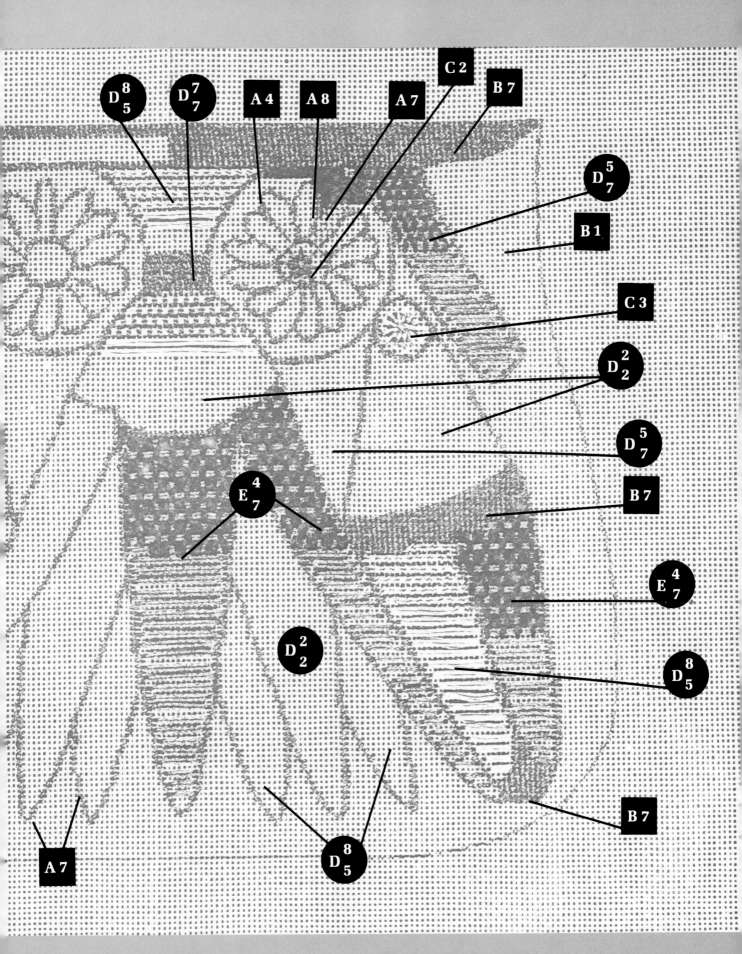

INSTRUCTIONS

Canvas: 16-mesh white mono canvas (12″ x 14″)
Needle: no. 18 tapestry
Stretcher: 12″ x 14″
Finished size: Approximately 7½″ x 9½″

DMC 6-Strand Cotton	*Other threads*
1. dark bright gold (741)	7. gold metallic
2. bright gold (742)	8. light blue Marlitt silk (1062)
3. medium bright blue (322)	
4. dark blue (796)	
5. medium dark blue (312)	
6. light blue (775)*	

*Color Numbers 6 and 8 are interchangeable; only 8 is specified on photo-pattern.

Working the design

Transfer the design and prepare to work using the method described under General Directions. For absolute symmetry, stitches should be counted.

1. Outline all areas in Continental (A), using gold metallic thread. Fill in outlined areas with Diagonal Tent (B) or Couched stitches (D, E) using key for stitches and colors on photo-pattern.

 D—2-over-2: Work in Single Couched stitch (D), using bright gold 6-strand cotton (2) laid over bright gold 6-strand cotton (2).

 E—4-over-7: Work in Double Couched stitch (E), using dark blue 6-strand cotton (4) laid over gold metallic (7).

NOTE: Always use 12 strands of 6-strand cotton and double the gold metallic threads for the laid areas.

Working areas marked C

Work Whipped Spider Web (C), using bright gold 6-strand cotton for center of flowers and medium bright blue for remaining two circles.

Working the background

Work in Diagonal Tent stitch (B), using dark bright gold 6-strand cotton.

NOTE: The mounted bag has a gusset about 1½ inches wide by 24½ inches long. It is worked in Couched stitch with laid gold and couched with dark bright gold.

94

TWIN JEWELED DAGGERS

*Two daggers with almost identical hilts were found
wrapped in King Tutankhamun's mummy. One has a blade
of gold; the other of iron, a rare metal found only
occasionally in Egypt during this period. The hilt of both
daggers is made of gold, inlaid with semiprecious stones
and glass-paste, alternated with beautiful colored bands of
cloisonné. In this adaptation, wool and metallic threads
are used to convey a close likeness to the original. It is
interesting that this same border design is seen in golden
objects found in other tombs of the period.*

TWIN JEWELED DAGGERS IS DESIGNED TO BE USED AS A LAMP
BASE, PILLOW, TOTEBAG, BOOK COVER, PLANTER COVER OR
BELT.

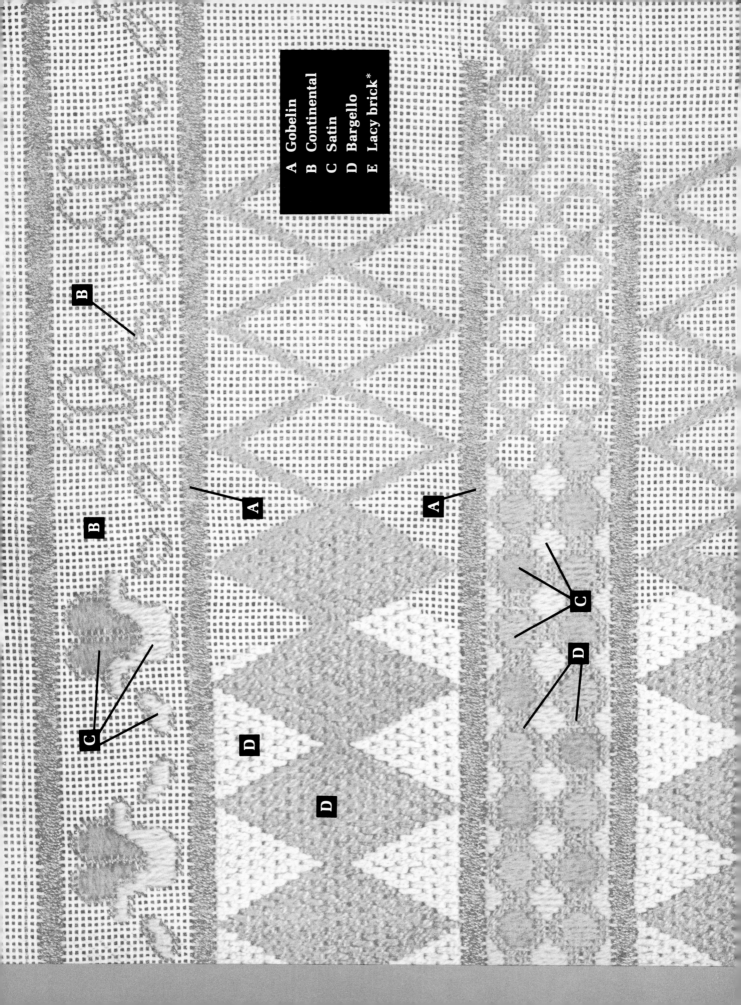

A Gobelin
B Continental
C Satin
D Bargello
E Lacy brick*

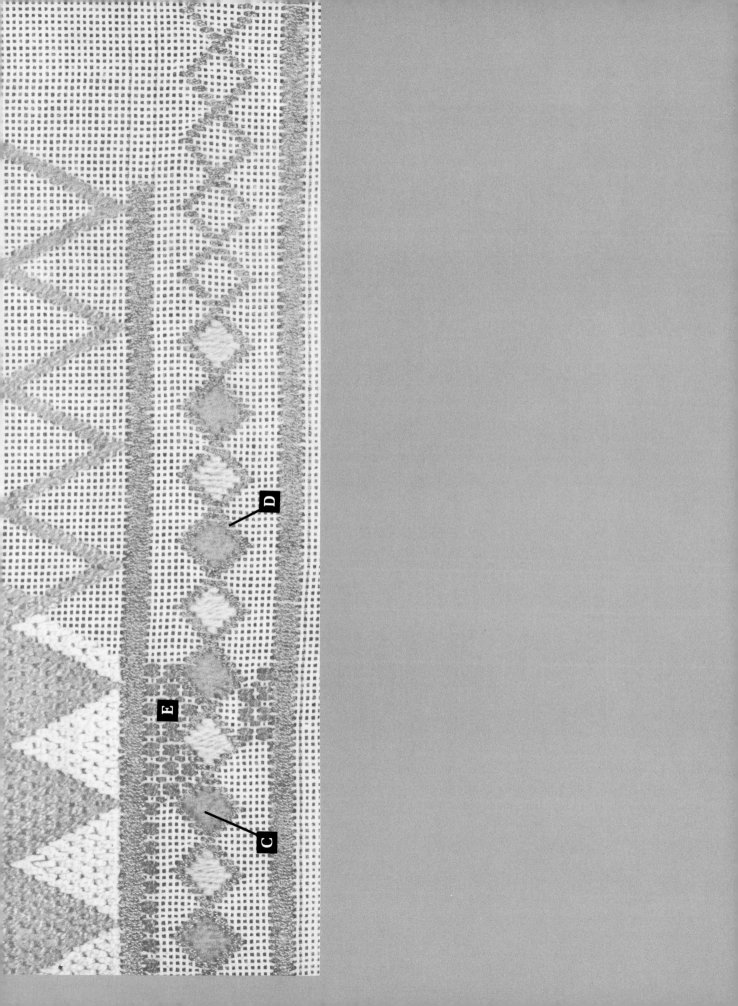

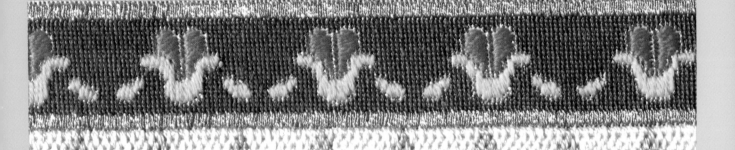

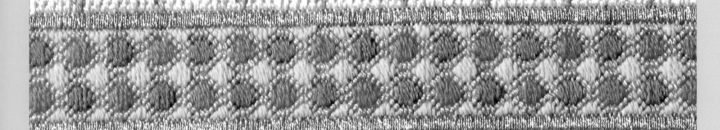

INSTRUCTIONS

Canvas: 14-mesh white mono canvas (desired length x 15″)
Needles: no. 20 tapestry for wool threads
 no. 18 tapestry for other threads
Stretcher: rotating tapestry frame
Finished size: desired length x 11″

Persian wool	*Other threads*
deep coral (958)	medium blue 6-strand DMC Cotton (797)
medium turquoise (738)	medium gold DMC Pearl Cotton no. 3. (729)
	ecru DMC Pearl Cotton no. 3
	gold metallic

Working the design

Prepare to work, using the method described under General Directions. NOTE: Each border is separated by a bar of medium gold Pearl Cotton, worked in Gobelin (A) over 4 canvas threads; and each has counted thread designs which can be graphed or counted directly from the photo-pattern.

1. Lotus flower border: Outline lotus and accent leaves in Continental (B), using gold metallic. Fill top part of the flower with horizontal Satin stitch (C), using 2 strands of deep coral wool. Fill bottom part of flower with vertical Satin stitch (C), using 2 strands of medium turquoise wool. Accent leaves with vertical Satin stitch (C), using 2 strands of medium turquoise wool. Work background in Continental stitch (B), using medium blue 6-strand cotton.

2. Large diamond border: Outline and fill diamonds in Bargello (D) over 4 canvas threads, using medium gold Pearl Cotton doubled. Work background in Bargello (D) over 4 canvas threads, using ecru Pearl Cotton doubled.

3. Rondel border: Outline rondels in Bargello (D) over 2 canvas threads, using medium gold Pearl Cotton. Fill rondels with Satin stitch (C), alternating 2 strands of medium turquoise and 2 of deep coral wool. Fill background with Satin stitch (C), using 2 strands of medium turquoise wool.

4. Second large diamond border: Repeat large diamond border from directions above.

5. Small diamond border: Outline small diamonds in Bargello (D) over 2 canvas threads, using gold metallic. Fill small diamonds with Satin stitch (C), alternating 2 strands of medium turquoise and 2 of deep coral wool. Fill background with lacy Brick stitch (E),* over 2 canvas threads, using medium blue 6-strand cotton doubled.

*See Glossary of New Stitches.

SACRED SCARAB

Among the most important of the amulets and ornaments worn by the ancient Egyptians were scarabs which have been found in abundance in the excavated tombs of the early kings of Egypt and derive their name and design from the dung beetle (Scarabaeus). These insects were sacred and symbolized resurrection, because they deposited their eggs on the corpse of another beetle, thus showing life coming out of death.

This adaptation was inspired by the "Birth of the Sun" pendant found in the wrappings of King Tutankhamun's mummy, which has an exquisitely crafted scarab worked in gold, lapis lazuli, carnelian, turquoise and green feldspar. The scarab is shown with legs, indicating it was made for a dead person. The curved base of the figure represents a boat on which the beetle is riding as he pushes the sun's disc over the horizon, signifying the king's crossing from earth into heaven. On either side of the beetle are the hieroglyphic symbols for stability, life and eternal youth.

THE SACRED SCARAB IS DESIGNED TO BE USED AS A WALL HANGING, PILLOW OR BACK FOR CHAIR.

INSTRUCTIONS

Canvas: 14-mesh white mono canvas (16″ x 19″)
Needles: no. 20 tapestry for wool threads
no. 18 tapestry for cotton and metallic threads
Stretcher: 16″ x 19″
Small amount of cardboard: 4″ in diameter; approximately ½″ in width

Finished size: 12″ x 15″

Persian wool
white
medium blue (752)
dark blue (323)

Other threads
DMC Pearl Cotton no. 3
 medium gold (729)
 navy (796)
 dark coral (920)

DMC 6-strand cotton
medium coral (921)
peach (945)
turquoise (966)

gold metallic

Working the design

Transfer the scarab, sun and boat designs to the canvas. The hieroglyphic bands on either side of the scarab may be traced or graphed and then transferred. Prepare to work, using the method described under General Directions.

1. Scarab: Outline the scarab's body and head in Chain stitch (A), using navy Pearl Cotton to outline the body, and medium gold Pearl Cotton to outline the head. Fill the head with horizontal Satin stitch (B), using 2 strands of dark blue wool. Work head detail in Chain stitch (A) over Satin stitch already worked, using medium gold Pearl Cotton.

2. Upper part of body: Work in Scarab stitch (C),* using 2 strands of medium blue wool for the understitch and alternating navy Pearl Cotton and turquoise 6-strand cotton doubled for the overstitch.

3. Lower body or wings: Work double vertical lines down center of lower body in Kalem stitch (D), using medium gold Pearl Cotton. Work single vertical lines in Continental (E), also using medium gold Pearl Cotton. Work single horizontal lines in Continental (E), using turquoise 6-strand cotton. Fill in blocks made by horizontal and vertical lines with

*See Glossary of New Stitches.

103

shaded Cashmere stitch (F), using 1 strand of dark blue wool for the dark half of the block and 1 strand of medium blue wool for the light half. Check photo-pattern carefully for the direction of stitches. Stitches on right side slant to right and on left side to left.

The dark area at the bottom of the beetle's body is outlined in Chain stitch (A), using navy Pearl Cotton. Lay long horizontal stitches to fill the area then couch down the center of the area in vertical Back stitch using 2 strands of dark blue wool.

4. Legs: Outline the legs in Chain stitch (A), using navy Pearl Cotton. Fill legs with the Cashmere (Variation) stitch (H),* using 1 strand of medium blue wool for the upper leg and navy Pearl Cotton for the lower leg.

5. Boat: Start in the middle of the boat and work to each side in double Brick stitch (I), using medium gold Pearl Cotton doubled. Outline around the Brick stitch with Stem stitch (J), again using medium gold Pearl Cotton.

6. Sun: Whip cardboard circle to the canvas with radiating Satin stitch (B), using dark coral Pearl Cotton. Work stitch closely so cardboard padding will be well covered. The design within the circle is worked in the Sunflower stitch (K),* using medium coral 6-strand cotton for the outside of the flower and gold metallic for the inside. Fill in the background of the sun in Continental (E), using peach 6-strand cotton.

7. Hieroglyphic bands: Work entire area in Continental (E). Use color photo as guide.

Working the border

Begin the border design at the top left corner, and work toward the center of the top and down the sides. See photo-pattern and color photo for details of border.

1. Alternating color band: Work in padded Gobelin (L) over 6 canvas threads, using 2 strands of dark blue wool. The corner is formed by 6 vertical and 6 horizontal canvas threads and is mitered.

2. Inside bands: The gold line inside the border design and around the sun is worked in Gobelin (L) over 2 canvas threads, and also shares a mesh with the inner edge of the border. Two rows of Gobelin over 2 canvas threads, one using 2 strands of white wool and one using navy Pearl Cotton, are worked inside the border and around the sun, ending at the tip of the boat. These rows also share meshes at their inner edges.

104

Working the background

Work in Gobelin (L), using 2 strands of white wool and working over 2 canvas threads and skipping 1 canvas thread between rows.

Working the gold frame

The outer gold frame around the entire design is worked in Gobelin (L), over 2 canvas threads, using medium gold Pearl Cotton. The inner edge of these stitches shares a mesh at the point where the outer edge of the border design stitches meet the outer gold frame (see photo-pattern). This avoids canvas threads peeking through.

*See Glossary of New Stitches.

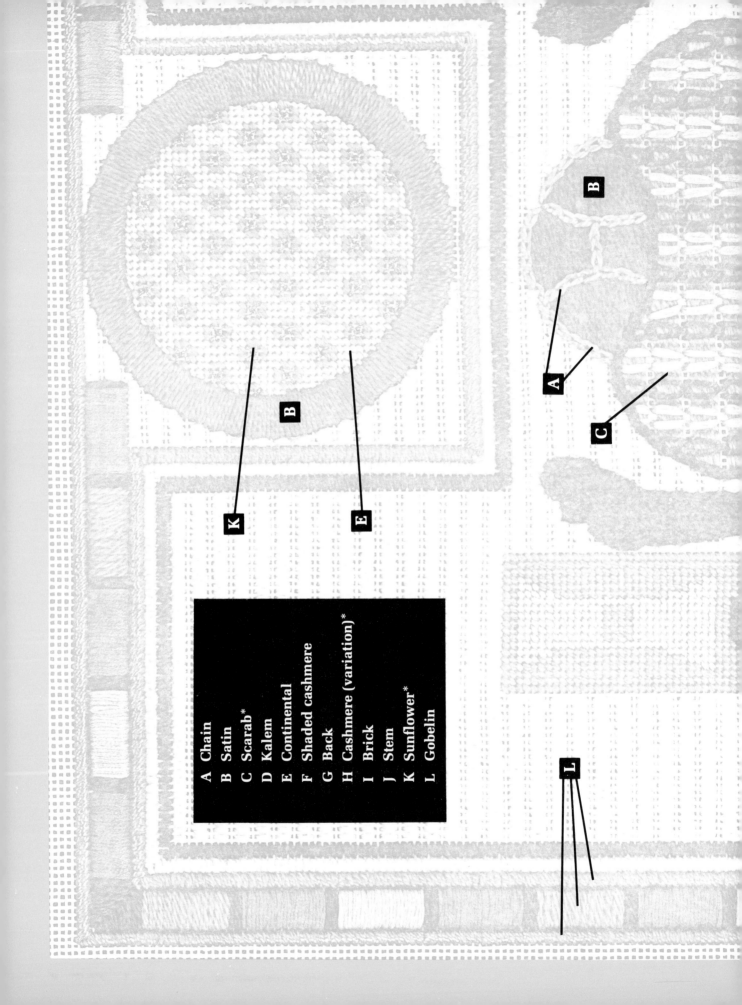

B

A

C

B

K

E

A Chain
B Satin
C Scarab*
D Kalem
E Continental
F Shaded cashmere
G Back
H Cashmere (variation)*
I Brick
J Stem
K Sunflower*
L Gobelin

L

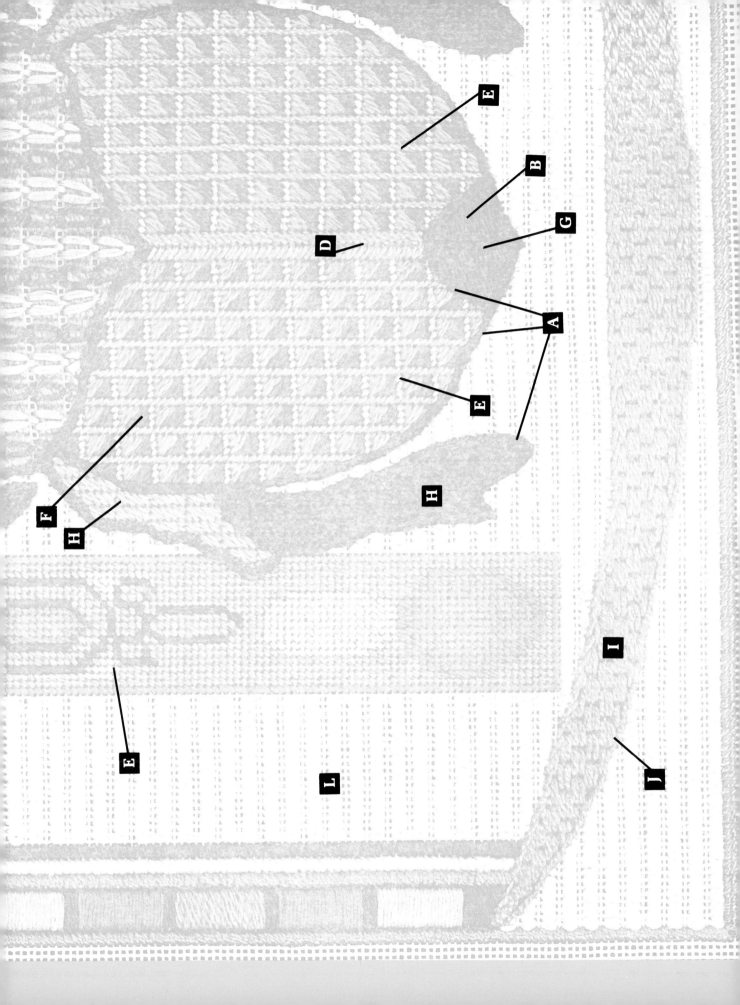

QUEEN'S PANEL

Queen Ankhesenamun was the lovely young wife of King Tutankhamun. It was probably through her that he ascended to the throne, and for this reason she is frequently shown accompanying him in various activities—these scenes always appealing portraits of a happy marriage. The drawing of the graceful figure of the young queen used for the overflap of this purse was taken from a panel of a little shrine found in the antechamber of King Tutankhamun's tomb. The shrine is completely plated in gold, and on all four sides are bas-reliefs of the couple shown in various domestic situations. In the one shown here the queen sits at the feet of her husband handing him arrows with which he is shooting ducks and geese. Note that the queen's elaborate headdress is adorned with a thick plait worn only by the offspring of royalty.

The border motif was inspired by one inlaid on the king's ecclesiastical throne, also found in the tomb.

THE QUEEN'S PANEL IS DESIGNED TO BE USED AS AN EVENING BAG, PILLOW OR ALBUM COVER.

INSTRUCTIONS

Canvas: 18-mesh ecru mono canvas (11″ x 14″) for the back and front flap; and another piece 11″ x 11″ for the inner front.

Needle: no. 18 tapestry

Stretcher: 11″ x 14″

Finished size: 7″ x 10″

Persian wool	*Other threads*
light beige Persian wool (020)	brown Pearl Cotton no. 3 (839)
	brown 6-strand cotton (839)
	light beige 6-strand cotton (3033)
	gold metallic, or gold 6-strand cotton (729)

Working the design

Transfer the design and shape of the flap of the purse, and prepare to work, using the method described under General Directions.

Figure of the queen: Outline all lines of the body and head in Continental (A), using gold metallic or gold 6-strand cotton. Work the eye in Continental (A), using brown 6-strand cotton. Fill the figure of the queen with Continental (A), using light beige 6-strand cotton. See color illustration for dark lines on dress.

Working the border design

Area 1: Work in Gobelin (B) over 6 canvas threads, using 2 strands of light beige wool.

Area 2: Work in Gobelin (B) over 3 canvas threads, using brown Pearl Cotton.

Area 3: Work in Gobelin (B) over 4 canvas threads, using 2 strands of light beige wool.

Area 4: Work 1 row of modified Mosaic Diamonds (C). See photo-pattern for exact canvas count of stitch, using 2 strands of light beige wool.
Background: Work in Bargello (D), using brown Pearl Cotton.
NOTE: There will be 2 rows of background Bargello which meet in a common mesh in the 3 meshes between each mosaic diamond. The background Bargello also shares the meshes around the edge of the diamond stitches.

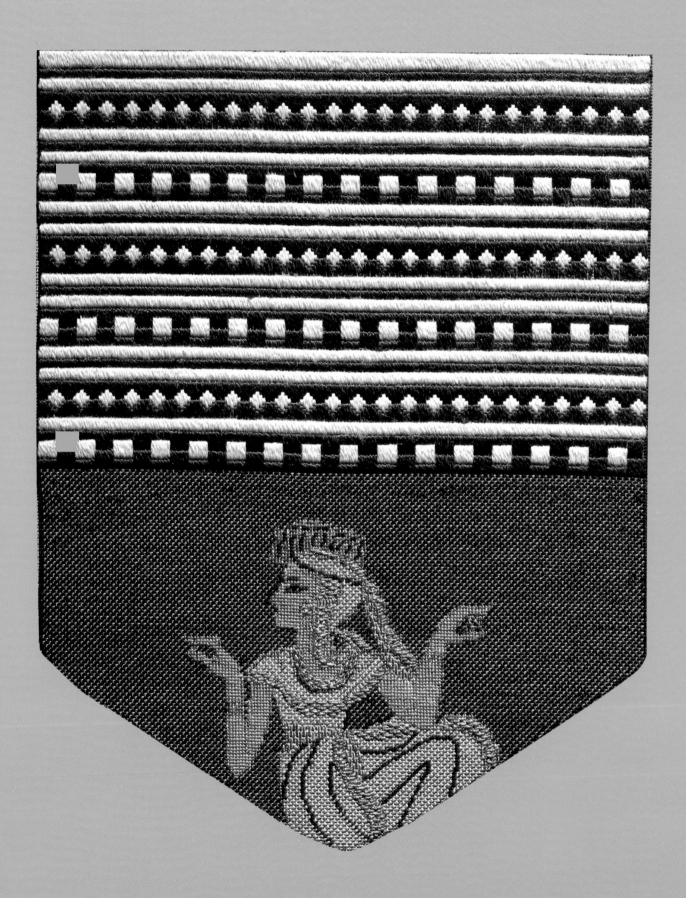

Area 5: Repeat areas 3, 2, and 3 again.

Area 6: Alternate blocks of light beige wool (2 strands) and brown Pearl Cotton. The blocks are worked over 6 horizontal canvas threads and over 5 vertical canvas threads. *Background*: Work in Gobelin (B) over 3 canvas threads, using brown Pearl Cotton to fill in the top and bottom of the area, once again sharing mesh with stitches above and below. See photo-pattern for number of repeats. End the border design with a row of Area 6.

Repeat this complete design for the inner front section of the purse.

Working the background

Work in Half-cross Skip Stitch (E),* using brown Pearl Cotton. The top row of the background will share a mesh with the last row of Area 6. See photo-pattern.

Working the frame

Work a frame in Gobelin (B) over 4 canvas threads, using brown Pearl Cotton all around the design.

*See Glossary of New Stitches.

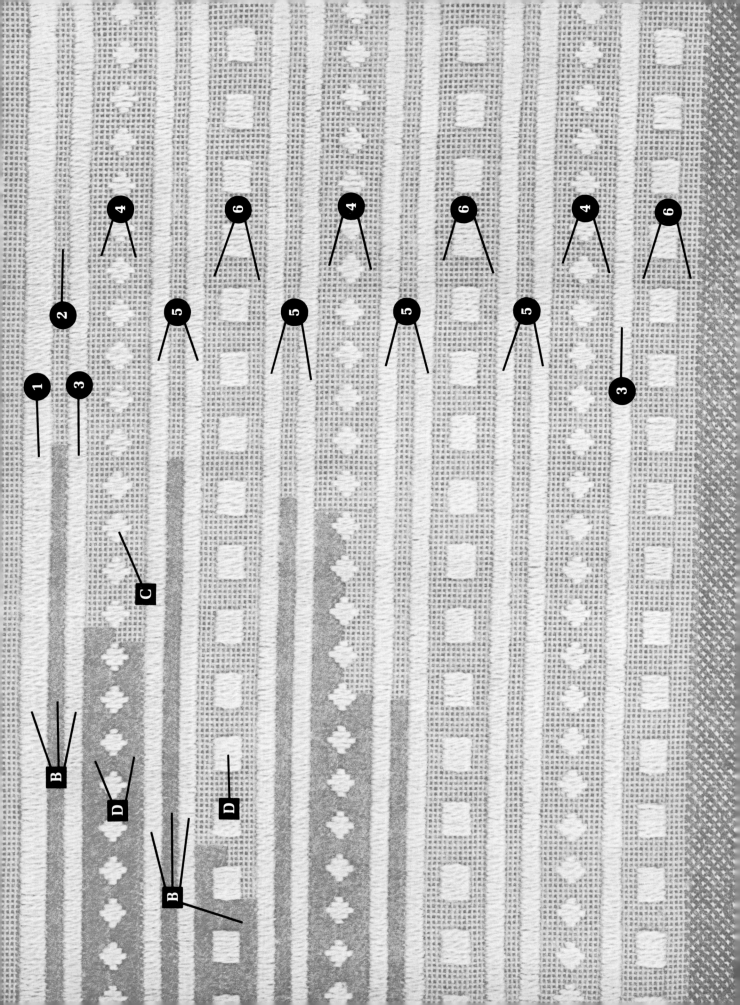

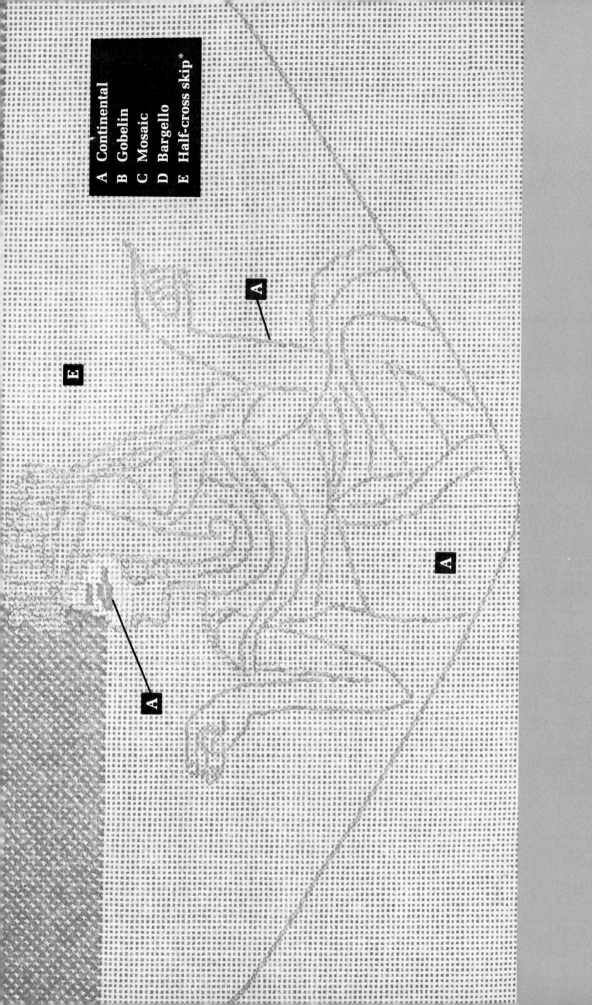

A Continental
B Gobelin
C Mosaic
D Bargello
E Half-cross skip*

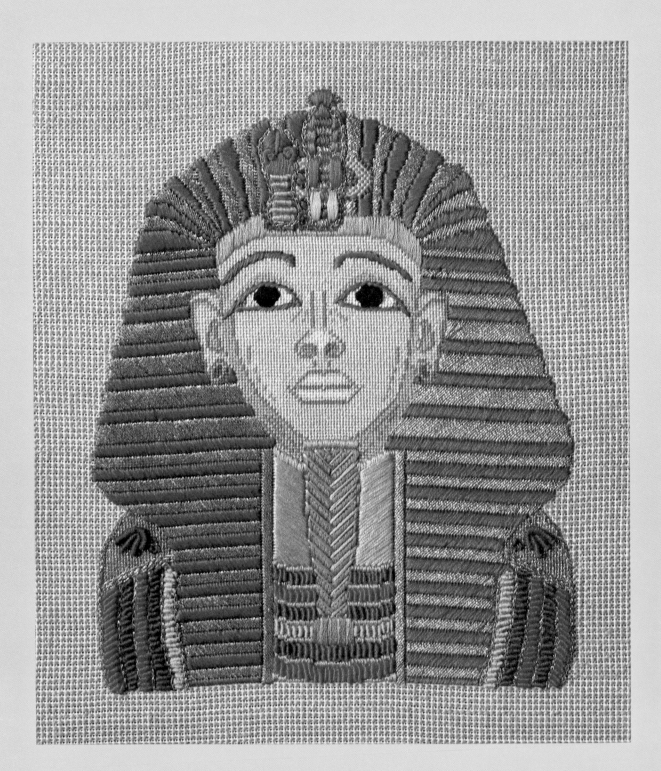

GOLDEN MASK

The golden Mask of King Tutankhamun is considered to be the most magnificent funerary mask ever discovered, and it is probably the most famous ancient art object known today.

The mask is thought to be an exact likeness of the seventeen-year-old Pharaoh. It was placed directly on the bandaged face of the young King's mummy and is made of beaten gold, inlaid with semiprecious stones and colored glass-paste. Framing the face is the "nemset" or burial headdress, which falls to the shoulders and down the front of the chest, and is tied in the back by a cord in the form of a queue. It is made of gold inlaid with lapis lazuli. On the forehead are two gold and colored stone figures representing the vulture "Nekhebet" and the cobra "Buko." These two creatures are the emblems of the two kingdoms over which King Tutankhamun reigned, and they represent his protective gods. The false beard is plaited in gold and lapis lazuli, and is also a symbol of the gods. The Pharaohs were traditionally clean shaven; false beards were worn only on state occasions or in burial dress. As a final touch to this magnificently executed example of the goldsmith's art is a handsome necklace made of lapis lazuli, quartz and feldspar, attached to the shoulders by two falcon heads.

THE GOLDEN MASK IS DESIGNED TO BE USED AS A WALL HANG-
ING OR PILLOW.

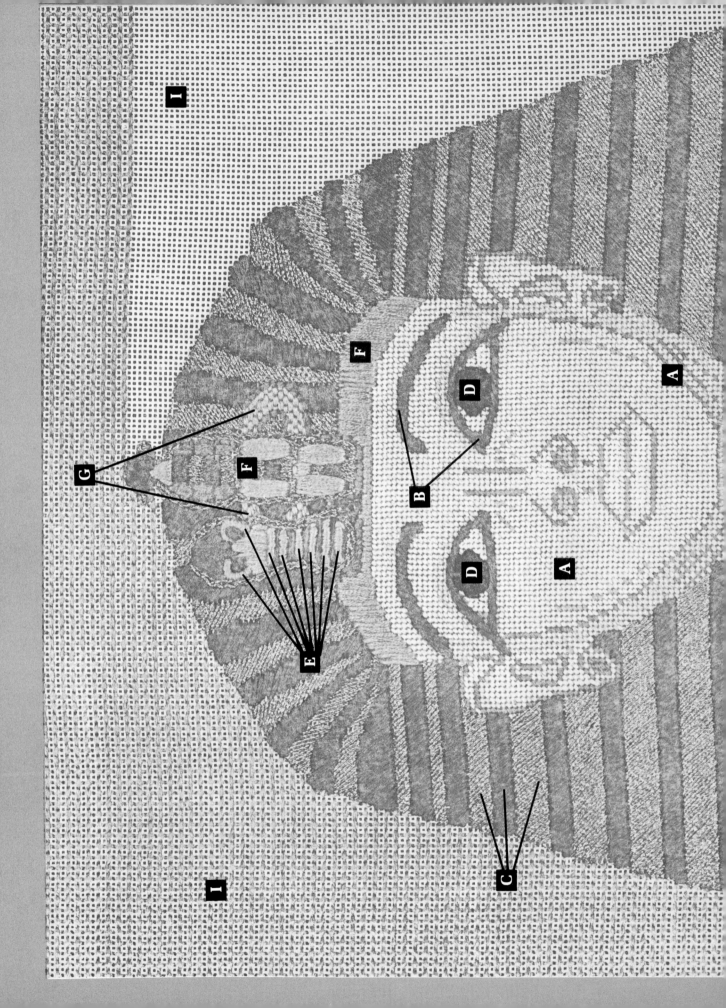

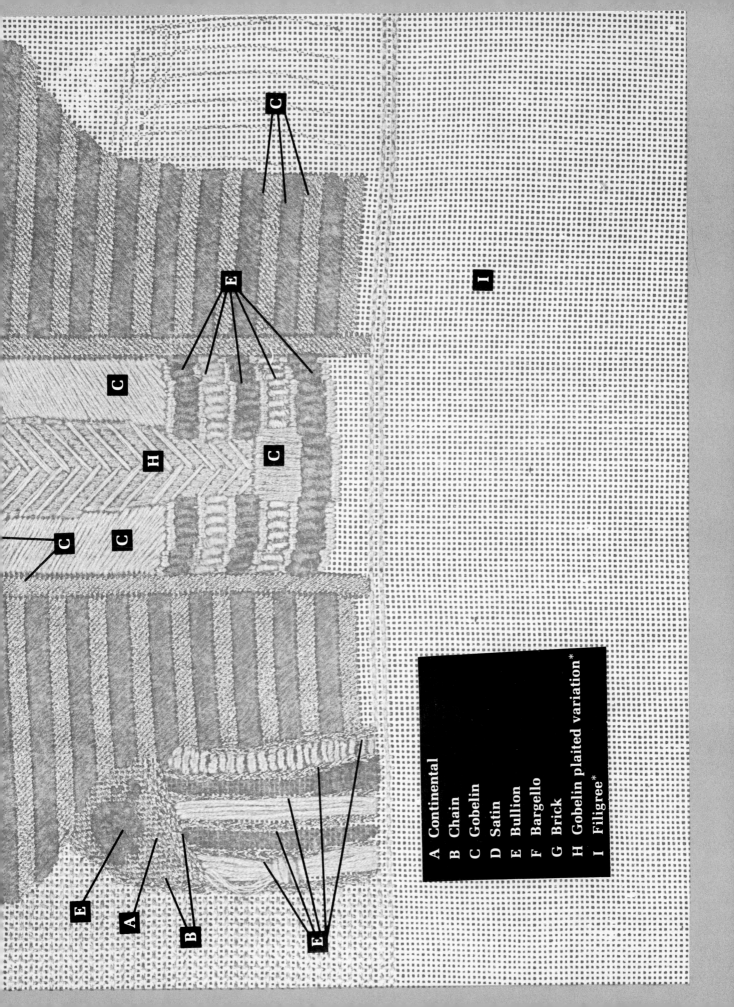

A Continental
B Chain
C Gobelin
D Satin
E Bullion
F Bargello
G Brick
H Gobelin plaited variation*
I Filigree*

INSTRUCTIONS

Canvas: 18-mesh white mono canvas (15″ x 17″)
Needle: no. 20 tapestry
Stretcher: 15″ x 17″
Finished size: 11″ x 13″

DMC 6-strand cotton

light aqua (932)
gold (729)
brown (801)
medium brown (976)
red (350)
turquoise (993)
dark turquoise (995)

navy (824)
flesh (738)
rosy beige (437)
medium rosy beige (436)
dark rosy beige (434)
black

Other threads
gold metallic

Working the design

Trace the design and transfer onto canvas, using the method described under General Directions.

1. Face: Outline ears, jawline, nose and mouth in Continental (A), using medium brown 6-strand cotton. Work cheek lines and bridge of nose lines in Continental (A), using dark rosy beige.

2. Gold metallic: Work all areas using gold metallic thread now. Outline the two figures on front of headdress in Chain stitch (B), using gold metallic. Outline right and left sides of necklace in Chain stitch (B), using gold metallic. Work gold stripes of headdress in slanted Gobelin (C), using gold metallic. See photo-pattern for direction of stitches. Note that stripes slant in opposite directions and stripes are of different widths. Work vertical lines on inner edge of headdress at neck in slanted Gobelin (C) over 4 canvas threads, using gold metallic. Work top of left and right sides of necklace in Continental (A), using gold metallic. Two half-circles of Bullions (E), using navy 6-strand cotton, are worked over this gold metallic background. Fill in blue stripes of headdress in slanted Gobelin (C), using navy 6-strand cotton.

3. Vulture and Cobra: Work 6 rows of Bullions (E), using gold 6-strand cotton for lower part of the vulture (left figure on headdress). Work middle in Bargello (F), using red 6-strand cotton. Work top of figure in Satin stitch (D), using navy 6-strand cotton. Work a row of Back stitch through center of this top area. Finish with 2 Bullions worked in red. For

figure of cobra (right figure on headdress) work in long and short Bargello stitches (F), using red, turquoise, navy, dark rosy beige 6-strand cotton, and gold metallic. See color illustration for placement of colors. The tail of the cobra is worked in Brick stitch (G), using gold 6-strand cotton. NOTE: A compensation stitch may be needed to fill in open spaces. Use brown 6-strand cotton if necessary.

4. Plaited Beard: Work in Gobelin-Plaited Bargello (H),* using dark turquoise 6-strand cotton for the understitch and gold 6-strand cotton for the overstitch. The bottom of the beard is worked in long Gobelin stitches (C), using dark turquoise 6-strand cotton for the understitch with 4 long gold stitches worked on top. See color illustration for detail.

5. Neck: Work in long slanted Gobelin stitches (C), using gold 6-strand cotton doubled. Stitches will share a mesh with the outer edges of the plaited beard and the inner edge of the two gold metallic vertical lines.

6. Necklace (left and right shoulder): Fill in between gold metallic lines of right and left sides of necklace with padded Bullions (E), using, from left to right: red, navy, red, navy and turquoise 6-strand cotton. Bullions will be horizontal. For the right side of the necklace work as above, but reverse colors to read from left to right: turquoise, navy, red, navy and red. For front of necklace, work 6 rows of Gobelin stitch (C), using gold 6-strand cotton. Use lines traced from photo-pattern as guide. Work 6 rows of Bullions (E) between these rows in the following order, reading from top to bottom: navy, red, navy, turquoise, navy and red. These Bullions will be vertical.

7. Eyes and Eyebrows: Outline in Chain stitch (B), using navy 6-strand cotton. Work iris in Satin stitch (D), using black 6-strand cotton. Work white of eye in Continental (A), using flesh 6-strand cotton.

NOTE: Work a few stitches of Continental (A), using dark rosy beige 6-strand cotton, in inner and outer corners of the eyes for accent.

8. Finishing the Face: Work band between face and headdress in Bargello Filler stitch (F), using gold 6-strand cotton. Work row of Gobelin stitch (C) over 3 canvas threads, using gold 6-strand cotton at top of plaited beard. Work a row of slanted Gobelin (C) over 4 canvas threads, using gold 6-strand cotton at top of neck. See photo-pattern for details. Highlight nose and mouth in Continental (A), using flesh 6-strand cotton. Shade nostrils, eyelids, inside of ear, earlobe, and lower jaw in Continental (A), using medium rosy beige 6-strand cotton. Use brown 6-strand cotton for the "hole" in earlobe. Fill in the remainder of the face in Continental (A), using rosy beige 6-strand cotton.

Working the background

Work in Filigree stitch (I),* using light aqua 6-strand cotton.

*See Glossary of New Stitches. 119

Hieroglyphs, or word pictures, were well developed at the
time of the first recorded Egyptian Dynasty (about 3200
B.C.). The earliest examples were found painted or engraved
on stone vessels and other objects, and were used mainly
for religious monuments and documents. Although several
hundred hieroglyphic symbols were used in the Egyptian
"alphabet," those shown in the following pages are the
ones most frequently repeated in their ancient writings.
The symbols were usually drawn and shaded with the
natural color of the object, although often in religious texts
they were colored simply blue or green. In royal tombs the
hieroglyphs which identify the name or title of a ruler or
deity are always framed by a cartouche.

PART III

HIEROGLYPHS

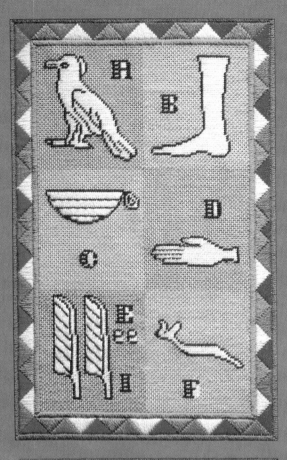

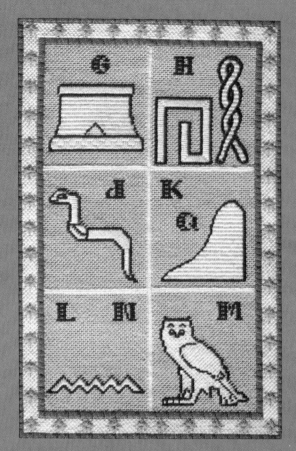

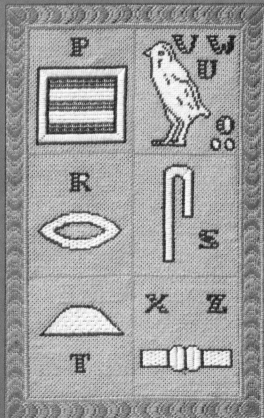

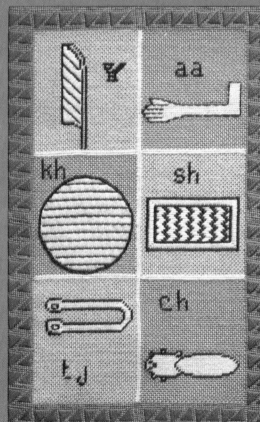

HIEROGLYPH SAMPLER

The hieroglyphs shown on the facing panels are the 24 alphabetic signs used in the old kingdom. If rendered imaginatively, these signs lend themselves to many uses. A modern alphabet is shown along with the hieroglyphs, and the combination of the two is meant to spark your imagination toward the making of interesting, personalized projects.

Alphabet	Hieroglyph
A	vulture
B	foot
C (cat)	basket
D	hand
E (ee) and I	two reed leaves
F	horned viper
G	pedestal for jar
H	courtyard; twisted flax (for emphatic H)
J	cobra
K and Q	hill slope
L and N	water
M	owl
P	stool (see from top)
O (oo) and W, V, U	quail chick
R	mouth
S	folded cloth
T	loaf
X and Z	door latch
Y	flowering reed (or double reeds, as E)
AA	forearm
Kh	(symbol meaning uncertain)
Sh	pool
Tj	tethering rope
Ch	animal's belly and tail

NOTE: This hieroglyphic system did not provide for the notation of vowels. Only consonants were recorded, and the sound of vowels was inserted while speaking. To clarify a word or verb, a scribe might add a small drawing at the end of the word. For instance, for the word "cup," in Egyptian "HENET," he might write HNT; thus, flax/water/loaf followed by the design of a cup. For the verb "to dance," in Egyptian "IB," he would write reed/foot followed by the drawing of a dancing girl. The English word "foot," in Egyptian "RED," would be written "RD"; thus, mouth/hand followed by the design of a foot. The scribe was interested in the beauty of his drawings and would probably put the two elongated letters mouth/hand on top of each other next to the design of the vertical foot.

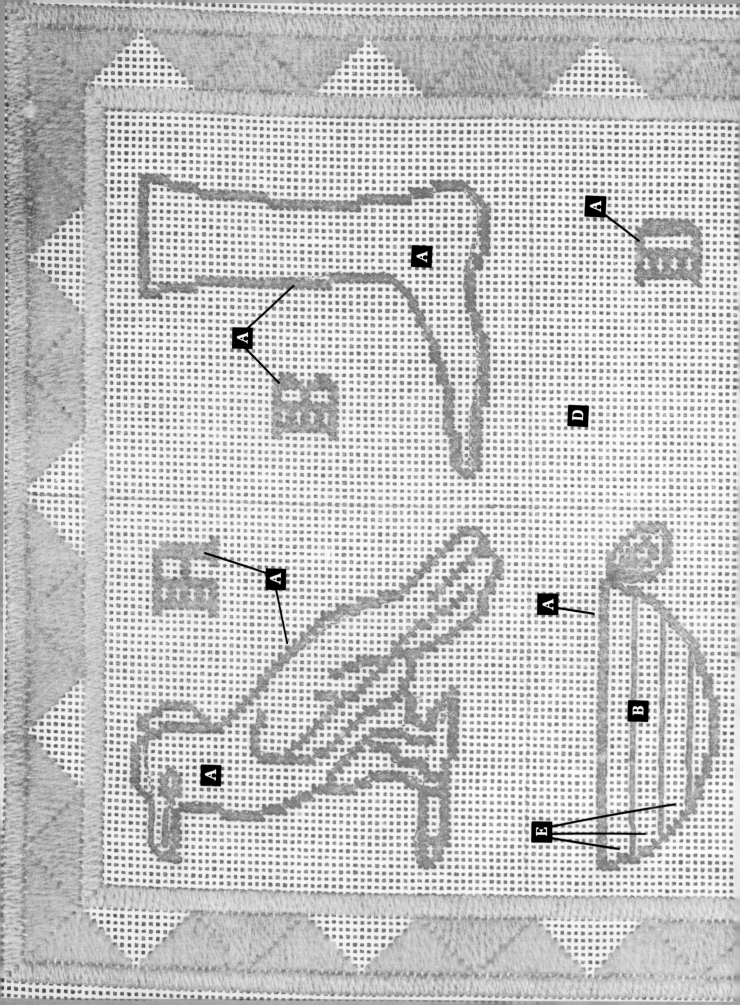

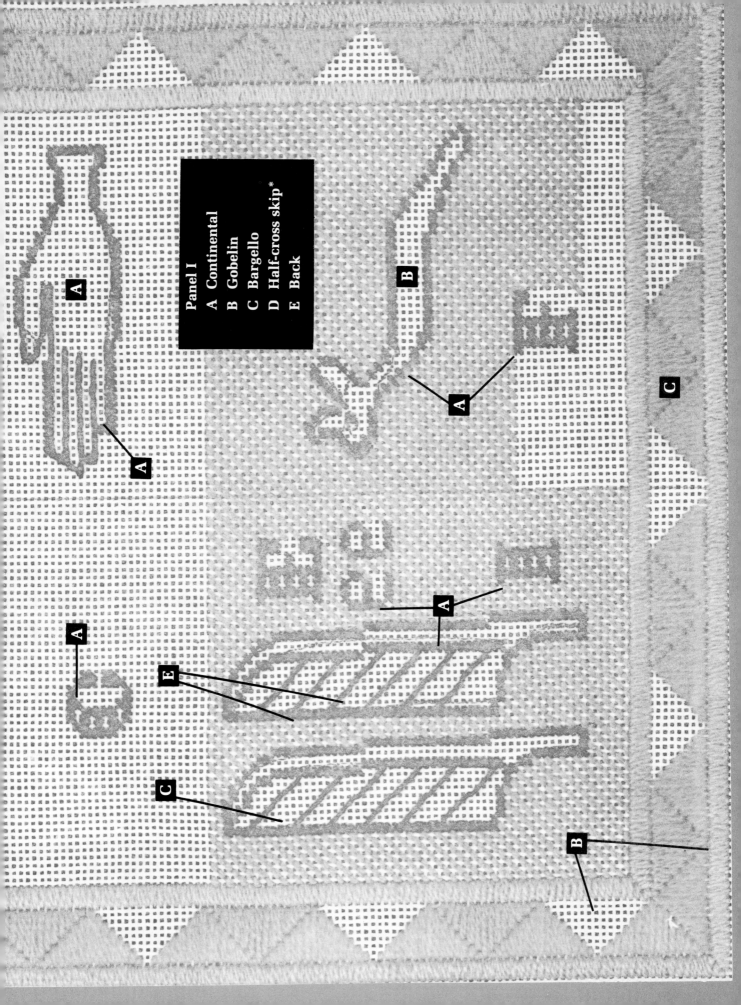

Panel I
A Continental
B Gobelin
C Bargello
D Half-cross skip*
E Back

INSTRUCTIONS

Each of the four hieroglyph samplers is worked in the same basic manner and they are designed to be used as a group. The color treatment and border designs differ to show variations that could be used. Color and border design directions are given with each panel.

Canvas: 14-mesh white mono canvas (15″ x 20″)
Needle: no. 18 tapestry
Stretcher: 15″ x 20″
Finished size: 10¼″ x 15½″

Threads
See individual panels.

Working the design

Mark off canvas into 6 segments. Each will be 54 canvas threads wide by 60 canvas threads long. Mark border around segments. The border will be 14 canvas threads wide.

Trace hieroglyphs or count stitches from photo-pattern. Letters of alphabet should be counted. Outline in Continental (A), using dark brown Pearl Cotton no. 3. Fill the hieroglyphs with white Pearl Cotton no. 3. Work the hieroglyphs in stitches keyed to individual panels.

PANEL I

Persian wool
bright medium green (574)
bright medium yellow (Y42)
medium coral (968)
medium gray green (569)
bright red (R10)
medium dark turquoise (728)
medium blue (752)
white

DMC Pearl Cotton no. 3
dark brown (938)
white

Working the design

Fill in hieroglyphs with stitches as keyed to photo-pattern, using white Pearl Cotton no. 3. Photo-pattern will also show details of stitch direction and length of Bargello and Gobelin stitches.

Working the border

Examine photo-pattern carefully before beginning border. Work inner frame of border in Gobelin stitch (B), over 3 canvas threads, using 2

strands of medium dark turquoise wool. Miter corners. Work outer frame of border in Gobelin stitch (B), over 3 canvas threads, using 2 strands of medium blue wool. Fill in between these two frames with Bargello stitch (C), alternating pyramids of medium gray green, medium coral, white and bright red wool. Use 2 strands of wool. The Bargello stitch forms pyramids 15 canvas mesh wide at the base. NOTE: The pyramid in the center of the top and bottom is 17 canvas mesh wide at base. In center of each side two small pyramids are joined to cover 27 canvas mesh.

Working the background

Work in Half-cross Skip stitch (D),* alternating bright medium yellow and bright medium green wool for the blocks. Use 2 strands of wool.

PANEL II

Persian wool	DMC Pearl Cotton no. 3
medium turquoise (738)	dark brown (938)
medium coral (968)	white
medium blue (752)	

Working the design

Work lines forming 6 segments in horizontal and vertical Kalem stitch (B), using white Pearl Cotton no. 3. Fill in hieroglyphs with stitches as keyed to photo-pattern, using white Pearl Cotton no. 3. Photo-pattern shows details of stitch direction and length of stitches.

Working the border

Work inner frame of border in Scottish stitch (E), over 3 canvas threads, alternating medium coral and medium blue wool. Use 2 strands of wool. Work outer frame in same manner. NOTE: Corners of outer frame are mitered over 5 canvas threads, using 2 strands of medium coral wool. Beginning at corner, work flowers of border in Eyelet stitch (G), over 7 canvas threads, using 2 strands of medium turquoise wool. These flowers are evenly spaced with 6 canvas threads between each one. NOTE: At center of top and bottom, flowers have only 2 canvas threads between. Fill in border background in Brick stitch (·D), over 2 canvas threads, using white Pearl Cotton no. 3.

Working the background

Work background in Half-cross Skip stitch (F),* using 2 strands of medium turquoise wool.

*See Glossary of New Stitches.

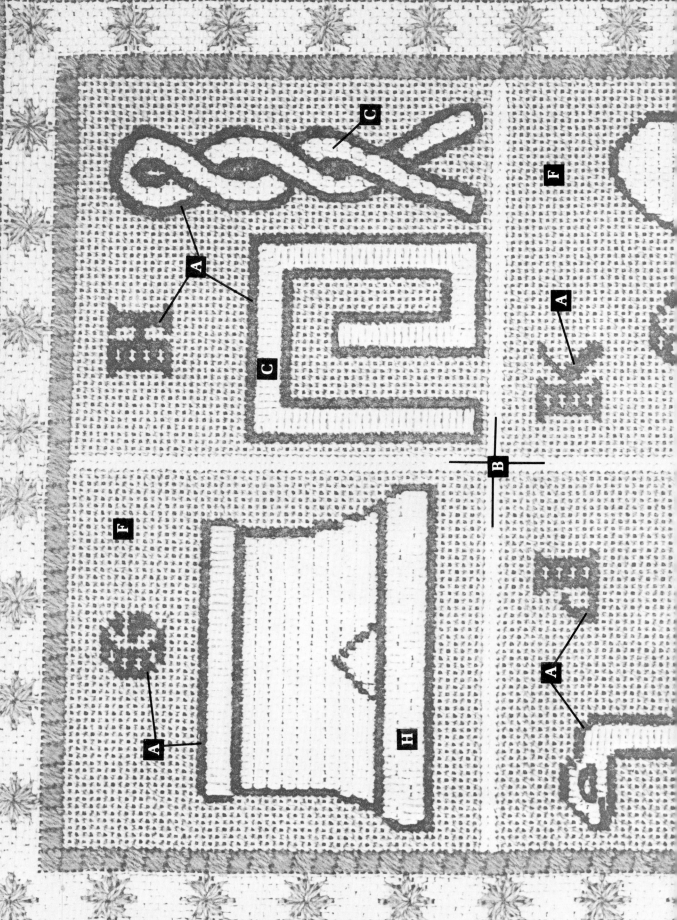

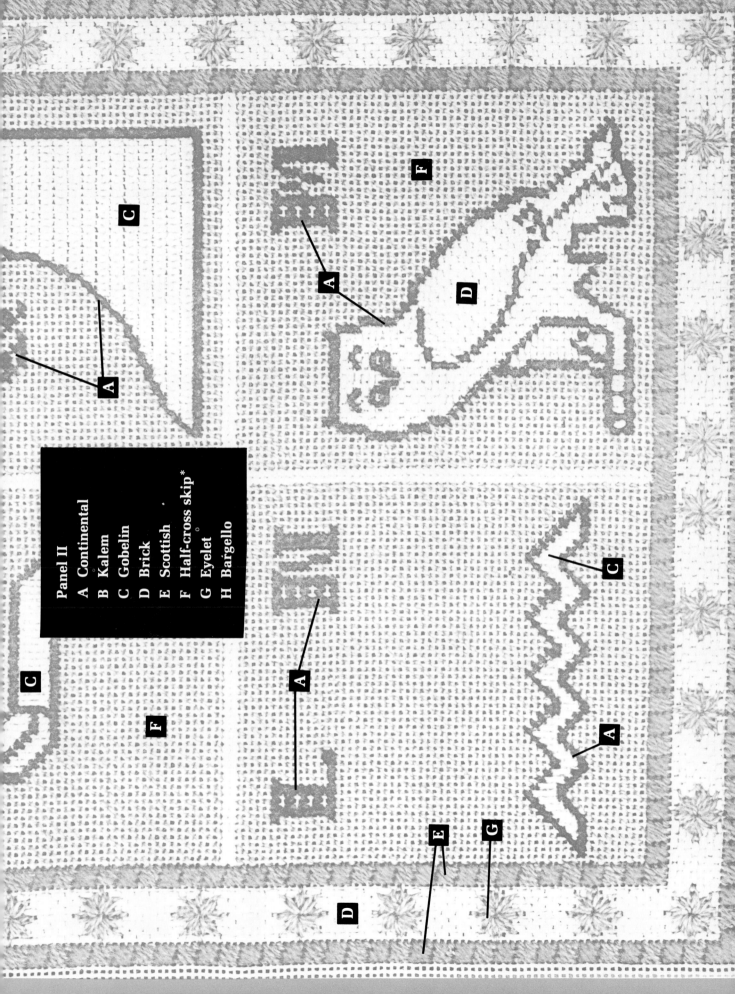

Panel II
A Continental
B Kalem °
C Gobelin
D Brick
E Scottish .
F Half-cross skip*
G Eyelet °
H Bargello

PANEL III

Persian wool
medium dark turquoise (728)
medium blue (752)
medium coral (968)

DMC Pearl Cotton no. 3
dark brown (938)
gold (729)
white

Working the design

Outline 6 segments in Continental (A), using gold Pearl Cotton no. 3. Fill in hieroglyphs with stitches as keyed to photo-pattern, using white Pearl Cotton no. 3. Photo-pattern shows details of stitch direction and length of Bargello and Gobelin stitches.

Working the border

Examine the photo-pattern carefully before beginning the border. The direction of the stitches changes in the center of the top, bottom and sides.

Work inner frame of border in Gobelin stitch (B), over 3 canvas threads, using gold Pearl Cotton no. 3. Miter corners. Work outer frame in same manner. Fill in between these two frames with Bargello stitch (C) worked in chevron pattern. Beginning at left corner alternate the following colors: gold Pearl Cotton worked over 2 canvas threads, 2 strands of medium blue wool worked over 4 canvas threads, gold over 2, medium dark turquoise wool over 4, gold over 2, medium coral wool over 4, repeat to center of canvas. Reverse direction of pattern and color sequence and repeat, working toward right corner. NOTE: Corner stitch, using strands of medium coral wool, is a mitered version of the chevron pattern.

Working the background

Work in Half-cross Skip stitch (F),* using 2 strands of medium dark turquoise wool.

130

PANEL IV

Persian wool
medium blue (752)
medium coral (968)
light coral (978)
light blue (793)

DMC Pearl Cotton no. 3
dark brown (938)
gold (729)
white

Other thread
medium blue DMC 6-strand cotton

Working the design

Outline the double horizontal and vertical segments in Continental (A), using white Pearl Cotton no. 3. Fill in hieroglyphs with stitches as keyed to photo-pattern. Photo-pattern shows details of stitch direction and length of Bargello and Gobelin stitches.

Working the border

Examine the photo-pattern carefully before beginning the border. Note the treatment of corners and middle of top, bottom and sides of border. Work inner and outer lines of border in Continental (A), using medium blue 6-strand cotton. Outline "Z" in Continental (A), using gold Pearl Cotton. See photo-pattern for stitch count. Border both sides of "Z" in Continental (A), using medium blue 6-strand cotton. Check photo-pattern for details. Fill in triangles in Triangular filling (E), alternating medium blue and medium coral wool. Use 2 strands. For the filling of the corners and centers of top, bottom and sides see color picture.

Working the background

Work in Half-cross Skip stitch (F),* using 2 strands of wool. Alternate blocks of light coral and light blue wool.

*See Glossary of New Stitches.

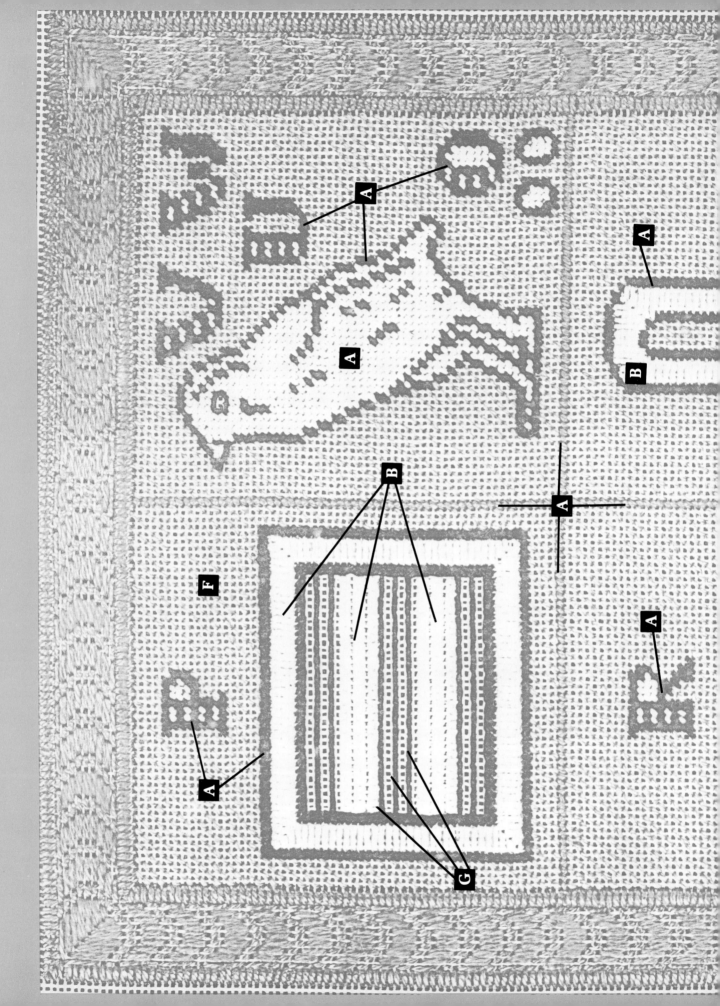

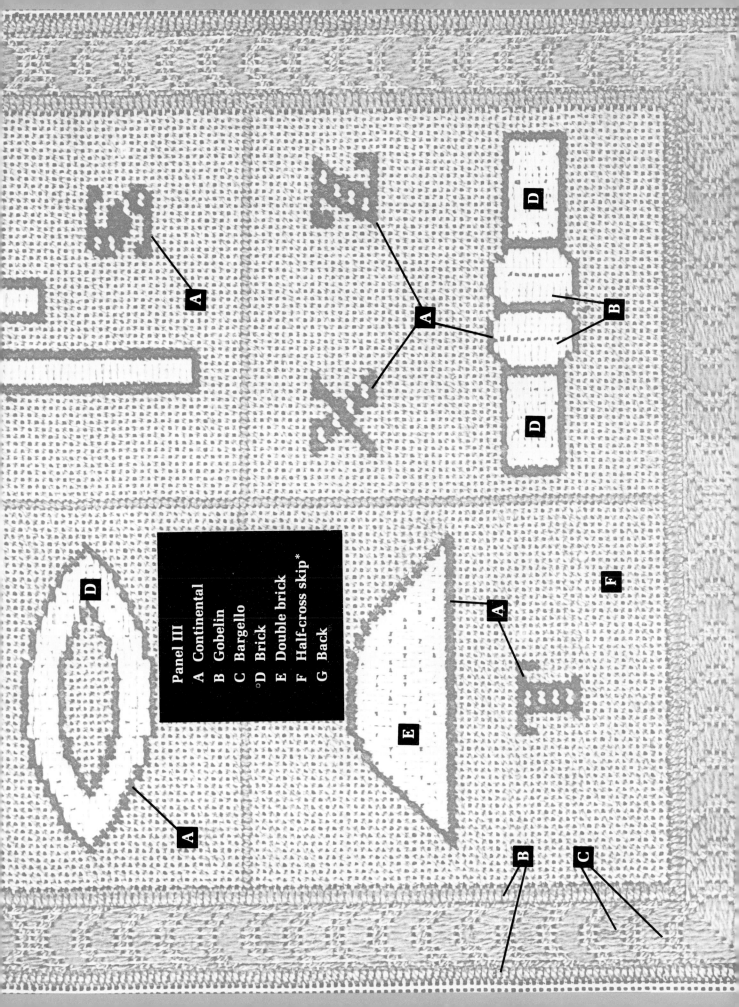

Panel III
A Continental
B Gobelin
C Bargello
°**D** Brick
E Double brick
F Half-cross skip*
G Back

Panel IV
A Continental
B Gobelin
C Bargello
D Back
E Triangular filling
F Half-cross skip*

INITIALED TOTEBAG

The ancient Egyptians used hieroglyphs to identify articles much in the way we use monograms today. This piece, designed for a totebag, is an example of an attractive way of combining the old with the new. The hieroglyphic symbols used here are the stool (seen from the top) for the modern initial P, and, resting on the stool, the horned viper for the modern initial F. The owl and the vulture, also hieroglyphic symbols, are used to enhance the design.

The mosaic border design was suggested by the frame painted around the hunting and battle scenes appearing on a chest in King Tutankhamun's tomb. The wooden chest, completely covered with brilliantly colored pictures and borders, was found in the antechamber of the tomb, and it was considered by the archaeologist Howard Carter to be one of the finest pieces discovered there. It was, in fact, the first object removed from the tomb for safekeeping.

INSTRUCTIONS

Canvas: 14-mesh white mono canvas (17″ x 19″)
Needles: no. 20 tapestry for wool threads
no. 18 tapestry for cotton and silk threads
Stretcher: 17″ x 19″
Finished size: 13″ x 15″

Persian wool	*Other threads*
beige (153)	rosy beige DMC Pearl Cotton no. 3 (437)
medium dark green (559)	dark brown DMC Pearl Cotton no. 3 (838)
turquoise (728)	beige DMC Pearl Cotton no. 3 (842)
medium dark beige (133)	yellow silk
dark brown (115)	rust velour or Persian wool
medium dark blue (742)	
4 tones of coral (952, 962,	
(972, and 982 or 992)	

Working the design

Choose the hieroglyphic symbols and initials to be used. Decide on the placement of the symbols. Transfer the symbols onto the canvas and prepare to work using the method described under General Directions.

Hieroglyphs: Outline the hieroglyphs in Continental (D), using dark brown Pearl Cotton. The hieroglyph may be worked freehand, or you may graph the symbol from the photo-pattern and work from that. Fill in the symbols with Continental (D), using 2 strands of wool in the following colors:
Vulture—medium dark blue, with yellow silk for eyes
Viper—turquoise
Owl—medium dark green, with yellow silk for eyes
Stool (worked around viper)—Outline in Gobelin (C), over 3 canvas threads using the darkest of the 4 coral tones on the frame only. Then working toward the center of the stool in Continental (D), work two rows of each of the remaining 3 tones of coral to complete the stool, using the color illustration as a guide.

Working the border design

NOTE: The complete border is not shown on photo-pattern. See color illustration for number of repeats and color sequence.

1. Work 6 rows of Diagonal Tent stitch (A) across the top of the canvas, using 2 strands of beige wool.

2. Work next 12 rows in Scottish stitch (B). There will be 3 rows of blocks, each row worked over 4 canvas threads. Alternate the 4 colors: rust, dark brown wool (2 strands), medium dark beige wool (2 strands), and rosy beige Pearl Cotton.

3. Next row, work straight Gobelin (C) over 2 canvas threads, using 2 strands of beige wool.

4. The next 11 rows are worked in Continental (D). Using the alphabet provided, graph the initials and work, using dark brown Pearl Cotton for them, and beige Pearl Cotton for the background area.

5. Repeat Step 1.

6. Repeat Steps 3, 2, 3, 4 and 5 for the desired size. If a longer bag is desired, add repeats, or use only one set if you prefer a shorter bag.

7. Bottom border design: Repeat Steps 3, 4, 3, and 2 twice, or the desired number of times. End with Step 1.

Working the background

Work in Diagonal Tent stitch (A) or Continental (D), using 2 strands of beige wool.

138

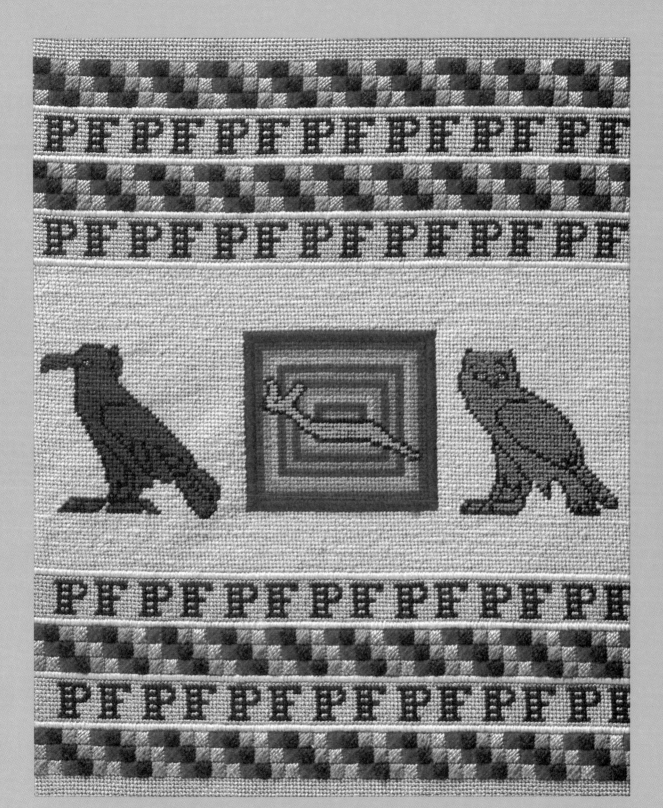

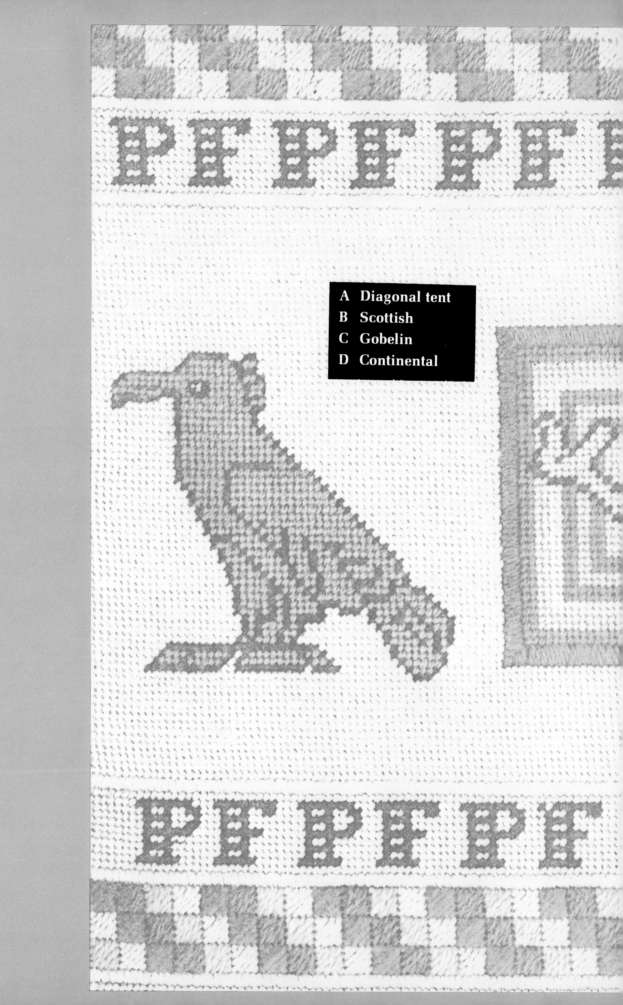

A Diagonal tent
B Scottish
C Gobelin
D Continental

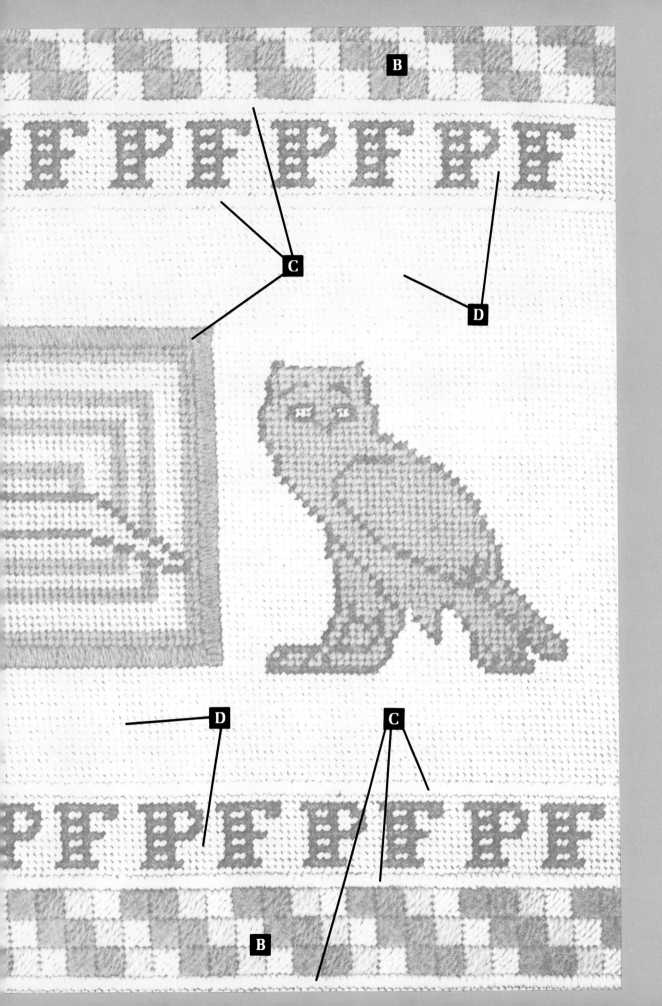

BELT AND BELTBAG

Another interesting way of personalizing with hieroglyphic symbols is shown on this belt design. The chevron repeat was inspired by a design found on an unguent box belonging to King Tutankhamun. The box is in the shape of a double cartouche and was probably used for ritual purposes.

The symbols for this purse are somewhat scaled down from the examples shown in the preceding Alphabet and Hieroglyph Sampler. Since the bag is worked on a smaller mesh canvas than the sampler, these hieroglyphs will have to be reduced and should be graphed or counted instead of traced. The textured background which is achieved through the combination of ecru canvas and ecru Pearl Cotton is worked in the new Half-cross Skip stitch.

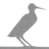

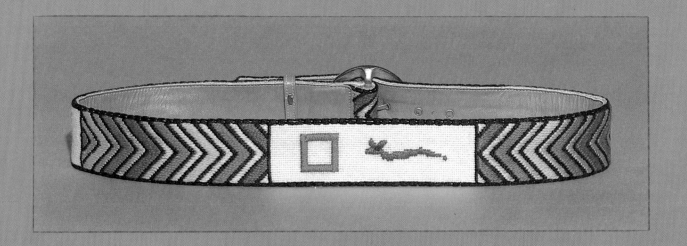

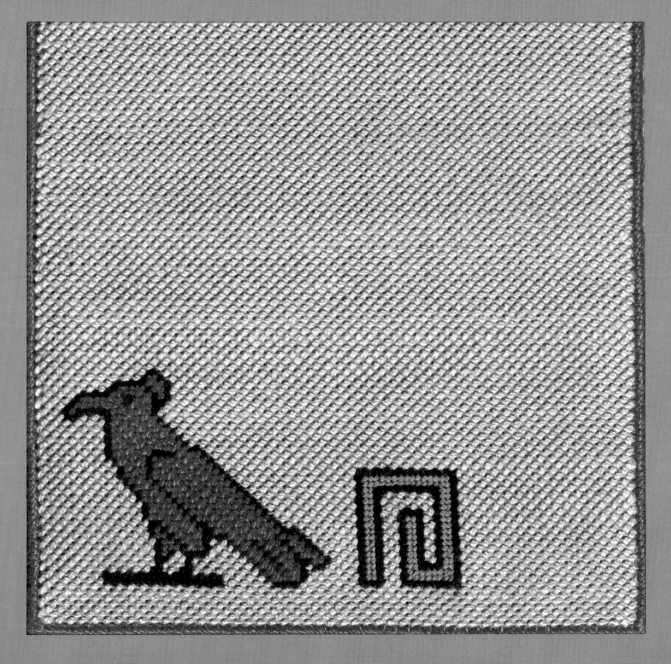

BELTBAG INSTRUCTIONS

Canvas: 16-mesh ecru mono canvas (11″ x 14″)
Needle: no. 18 tapestry
Stretcher: 11″ x 14″
Finished size: 6¾″ x 10¼″

DMC Pearl Cotton no. 3	*Other thread*
light ecru (738)	black DMC 6-strand cotton
rust (920)	
dark turquoise (995)	

Working the design

Choose symbols from Hieroglyph Sampler, reduce and transfer to canvas. Prepare to work, using the method described under General Directions.

1. Outline symbols in Continental (A), using black 6-strand cotton.

2. Fill symbol with Diagonal Mosaic stitch (B) worked on the diagonal, using rust Pearl Cotton. Alternate working over 1 canvas thread and then over 2.

3. Fill second symbol in Continental (A), using dark turquoise Pearl Cotton.

Working the background

Work in Half-cross Skip stitch (C),* using light ecru Pearl Cotton.

Working the border

Work a border around the entire piece in straight Gobelin (D) over 3 canvas threads, using rust Pearl Cotton. Miter the corners.

*See Glossary of New Stitches.

A Continental
B Diagonal mosaic
C Half-cross skip*
D Gobelin

A Gobelin
B Continental
C Bargello
D Back

BELT INSTRUCTIONS

Canvas: 16-mesh white mono canvas (5″ x desired length of belt)

Needle: no. 18 tapestry

Stretcher: rotating tapestry frame

Finished size: approximately 2¼″ x desired length of belt

Persian wool	*DMC 6-strand cotton*
aqua (322)	gold (729)
red (960)	black
blue (731)	
sand (455)	
colors of own choice for symbols	

Working the design

Select symbols to be used and calculate length of finished belt. Graph the design—both symbols and chevron stripes—to fit into desired length of belt. Transfer symbols onto canvas and prepare to work, using the method described under General Directions.

146

1. Hieroglyphs: Work symbols in Gobelin (A), using 2 strands of wool in colors preferred.

Working the background

Work in Continental (B), using 2 strands of sand wool. (Hieroglyphs and sand background area will measure about 5¾".)

Working the chevrons

See photo-pattern for direction of chevrons before beginning. Work chevrons on each side of hieroglyphic symbols, starting with stripe nearest symbol and working outward. Lengthen the two sets on the ends of the belt if necessary by adding repeats of sequence. Stripes are number-keyed for color. All stripes are worked in Bargello (C) in following sequence:

1. Black stripe: Work over 2 canvas threads, using 12 strands of 6-strand cotton and spacing stripes as shown on photo-pattern.

2. Gold Stripe: Work over 4 canvas threads, using 12 strands of 6-strand cotton.
Repeat Step 1.

3. Aqua stripe: Work over 6 canvas threads, using 2 strands of wool. Repeat Steps 1, 2 and 1.

4. Same as Step 3, substituting 2 strands of blue wool for aqua. Repeat Steps 1, 2 and 1.

5. Same as Step 3, substituting 2 strands of red wool for aqua. Repeat sequence again.

Working the frame

Work a row of straight Gobelin (A) around the belt over 3 canvas threads, using 12 strands of gold 6-strand cotton. Work one back stitch in black over 4 canvas threads (D).

*See Glossary of New Stitches.

STITCH GLOSSARY

In this section you will find many of the stitches used to create the unusual needlepoint paintings shown on the preceding pages. Some of the stitches are new, created especially for this book. Some are variations or combinations of stitches and they are identified with an asterisk (*) in the instructions and on the photo-patterns. Those which are unmarked cover the range of the unusual, yet more standard, stitches that were used. Other traditional stitches shown in the photo-patterns, such as the Brick, Bargello, Continental and Gobelin, can easily be recognized by the more experienced needleworker, and if there are any questions as to how to work them, the answers can be found in practically all of the stitch reference books appearing on page 14 of this volume.

The stitches

NOTE: On all the diagrams that follow, the odd numbered spaces are those through which the thread is drawn from the back of the canvas to the front, and the even numbered ones are those drawn from the front of the canvas to the back.

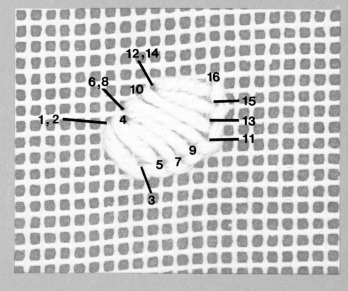

BUTTONHOLE

Buttonhole Feather Variation

Buttonhole stitches are looped stitches worked in a series of varying lengths. Here the stitch is worked in an oval to shape the feathered wings in Marching Geese.

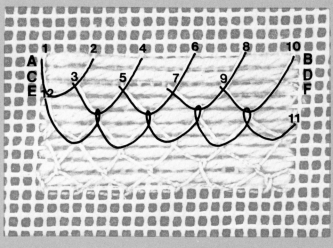

Buttonhole Filling-Open

An open diamond pattern of Buttonhole Stitches worked over a foundation of horizontal Laid Work, with the stitches looped around each other. Only those that follow the outside contour of the basic shape are attached to the canvas, leaving a detached section in the middle.

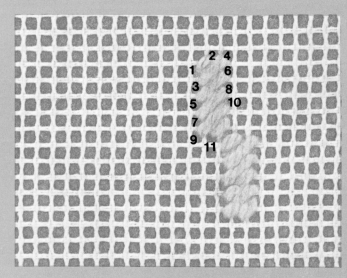

CASHMERE

Cashmere (Variation)

This Cashmere stitch is worked in a rectangular shape, starting with 1 slanted stitch over 1 intersection. The second stitch is over 2 intersections. Four long stitches are worked over 2, finishing with 1 short stitch over 1 intersection.

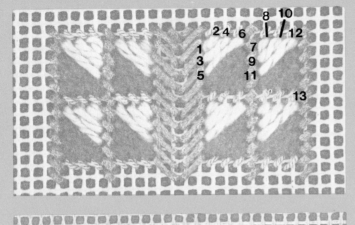
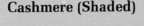

Cashmere (Shaded)

This variation of the Cashmere Stitch fits within a frame. Work in two colors changing direction from left to right as shown.

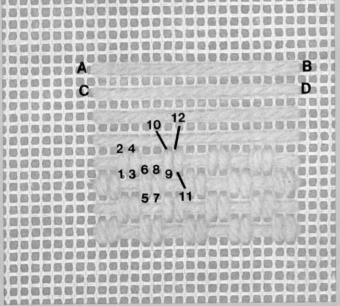

COUCHING

Egyptian Couching

Texture and shading are achieved with two colors and extra padding in the couching stitch used on Bast the Cat. In the accompanying illustration a single laid stitch is covered with short vertical stitches skipping two canvas threads between each pair and alternating vertical pairs between each row. Work two rows simultaneously.

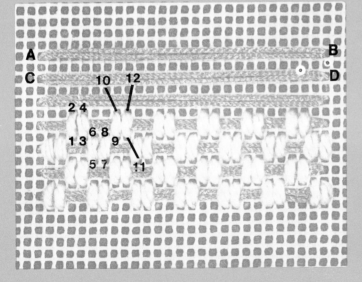

Double Couching (Or Nué)

Lay doubled metallic thread across design, skipping 2 canvas threads between each row. Work 2 short vertical stitches over 2 canvas threads in horizontal rows skipping 2 canvas threads, leaving gold thread showing through. Two rows are worked together.

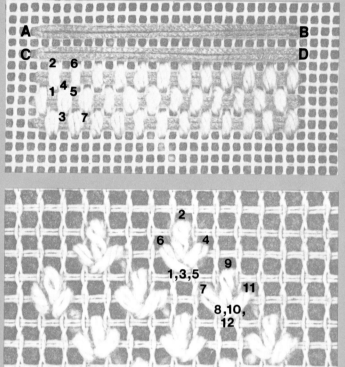

Single Couching

Work as for above, using 1 short vertical stitch over the Laid Work.

Dart

This lacy filling stitch is also good for backgrounds. A series of short vertical and diagonal stitches are placed in the order shown with the point of each group of 3 stitches sharing a common canvas space. Rows are worked on a slant to avoid excess threads on reverse side.

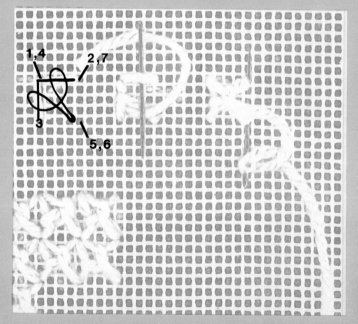

Egyptian or Eastern

This ancient stitch, discovered in Tut's tomb, appeared as a braided edge on the King's garments. Though not shown on the Ram's Head design, it can be used for the border.

The stitch is worked from left to right over 4 canvas threads, both widthwise and lengthwise. Bring needle out at 1, in at 2, out at 3, in at 4, out at 5. Loop thread over 1–3 and 1–2 and put needle in at 6. The next stitch begins at 7.

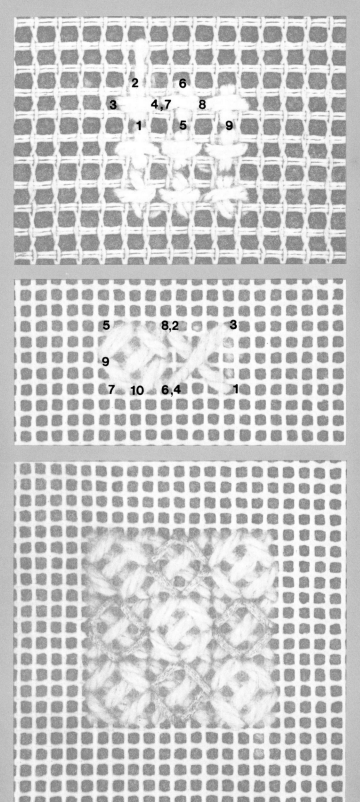

Filigree

This lacy upright Cross stitch is excellent for backgrounds. Interesting effects can be achieved by using different colors of canvas and thin or thick thread; regular tension is important. Work rows horizontally or vertically, leaving a blank space between rows as shown.

Flower Rice Variation (Crossed Corners)

This stitch uses a Cross stitch as a base. The corners are re-crossed diagonally. In this pattern every other cross is re-crossed in a constrasting color as shown. This produces the shaded, shimmering effect in Nefertiti's headdress.

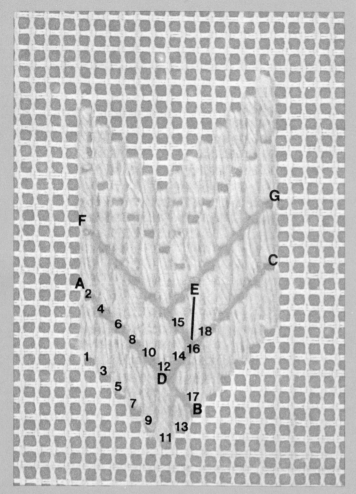

Gobelin-Plaited Bargello

The center row of wool stitches is worked over 2 canvas threads, and all other stitches are worked over 4. A long slanted overstitch in a contrasting silk creates the effect of braids seen in the gold mask.

Half-Cross Skip

The lacy effect of this simple stitch is achieved by skipping canvas threads; texture will vary according to materials used. The Leopard's face is stitched with thick wool, almost overlapping the empty spaces, while the backgrounds of the Beltbag and Queen's Panel use cotton threads to produce a different effect. Work from left to right, alternating the placement of the stitches on each row and always skipping one thread of the canvas between each stitch.

Ibex

Groups of 4 stitches, 2 vertical and 2 diagonal, with 1 vertical and 1 diagonal within each group sharing a common canvas space. This is a sheer stitch best worked in alternating rows to show the least possible thread through the canvas.

Isis

Another lacy filling stitch, Isis is characterized by an open diamond between the stitch groups. The pattern is worked with 4 short diagonal stitches intersecting in the center. Work each row on a diagonal, and take care to begin new stitches where minimum threads show through canvas.

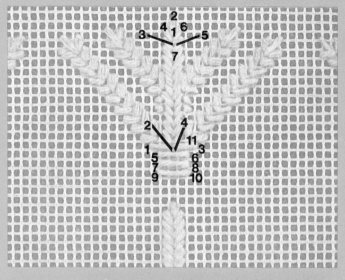

Kalem Lotus

This pattern is a variation of the Kalem stitch where the large design is formed by following the numbers on the chart. Work stem first, followed by base, then branches. Weave thread into back of design to reach new working areas. Begin again for each flower.

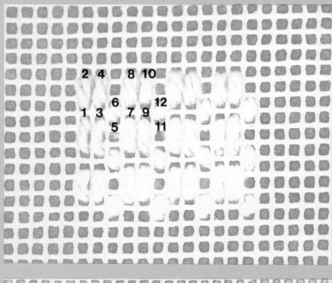

Lacy Brick

Work two rows of 2 straight stitches over 2 canvas threads, then one row of 1 straight stitch over 1 canvas thread, starting each of the stitches on this row in the free space just below the one where each of the longer straight stitches were started on the two adjacent rows.

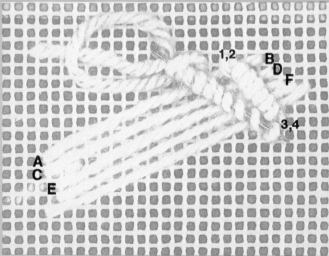

Padded Bullion

This Padded Bullion is worked with 6 strands of yarn and a large rug needle over diagonal rows of Laid Work. Number of strands and coils around needle may be varied according to texture desired.

Papyrus

This sheer stitch is made up of a series of long stitches arranged in an open fan shape with one end of each stitch worked through a common center space. Care must be taken to avoid threads showing through canvas.

Pebble

In Marching Geese from Medum, the pebbled background is achieved by using No. 3 Pearl Cotton on a fine-mesh canvas. Work 2 Gobelin stitches over two canvas threads, leaving two free canvas spaces between each group of stitches. Alternate the placement of the stitches and the free spaces on each row of the pattern. Two rows are worked together.

Pulled-thread

Pulled-thread work is a method of stitchery which creates a lacy effect by means of tension. Follow the illustration, pulling the thread after each stitch. Be careful to weave in any loose threads on the back as invisibly as possible.

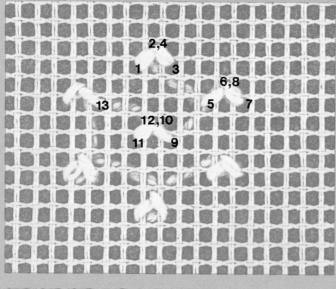

PYRAMID

A lacy filling stitch. Follow the numbering of the diagram which has been designed so that the minimum amount of thread will show through, spacing the stitches equidistantly over the area to be filled.

Single Pyramid

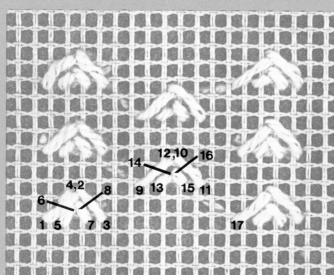

Double Pyramid

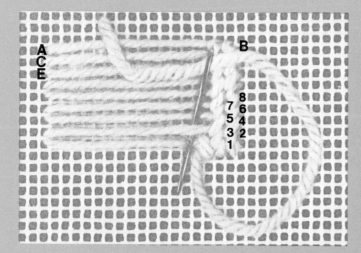

Raised Stem

A series of vertical stem stitches over a foundation of horizontal Laid Work. Work from bottom up. Weave thread back to base to begin second row.

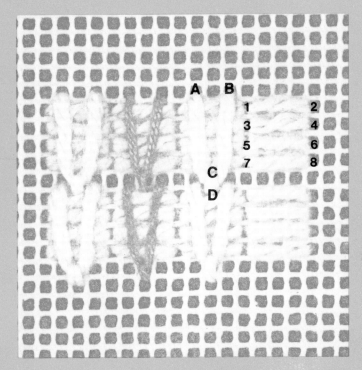

Scarab

A group of 4 horizontal stitches is worked over four canvas threads with one row of spaces left free between each group. A long horizontal Fly Stitch is worked over the center of each group of stitches and tied down at the end.

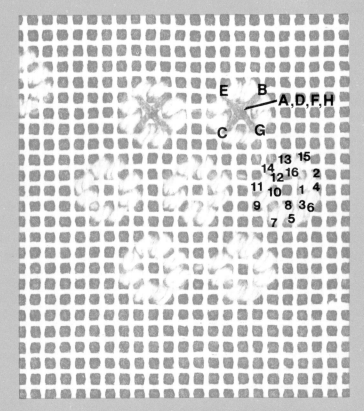

Sunflower

A group of 8 Continental stitches are placed to form a round. The center is filled with 4 short diagonal stitches intersecting at the center (see Isis stitch).

INDEX